Steve Holzner

D1246491

Sams **Teach Yourself**

Flickr®

in **10 Minutes**

SAMS | 800 East 96th Street, Indianapolis, Indiana 46240

Associate Publisher
Greg Wiegand

Acquisitions Editor
Laura Norman

Development Editor
Keith Cline

Managing Editor
Patrick Kanouse

Project Editor
Jennifer Gallant

Copy Editor
Keith Cline

Indexer
Erika Millen

Proofreader
Jovana San Nicolas-Shirley

Technical Editor
Christian Kenyeres

Publishing Coordinator
Cindy Teeters

Book Designer
Anne Jones

Compositor
TnT Design, Inc.

Contents

About the Author

Steve Holzner is the award-winning author of many science and tech books. His books have sold more than 3 million copies in 18 languages around the world, and he's been on the MIT writing faculty. He got his Ph.D. from Cornell University.

Steve is an avid photographer, exploring all kinds of formats and effects, and he's been a long-time Flickr member. Within the past couple of years, he's been interested in video and has been pleased to see Flickr expand their capabilities in that direction. He hopes they'll keep going.

Dedication

To Nancy, of course!

Acknowledgments

The book you hold in your hands is the product of many peoples' work. I'd especially like to thank Laura Norman, acquisition editor extraordinaire; Keith Cline, development editor and copy editor; and Jennifer Gallant, project editor, who made sure everything was where it should be when it should be.

We Want to Hear from You!

As the reader of this book, *you* are our most important critic and commentator. We value your opinion and want to know what we're doing right, what we could do better, what areas you'd like to see us publish in, and any other words of wisdom you're willing to pass our way.

You can email or write me directly to let me know what you did or didn't like about this book—as well as what we can do to make our books stronger.

Please note that I cannot help you with technical problems related to the topic of this book, and that due to the high volume of mail I receive, I might not be able to reply to every message.

When you write, please be sure to include this book's title and author as well as your name and phone number or email address. I will carefully review your comments and share them with the author and editors who worked on the book.

E-mail: consumer@samspublishing.com

Mail: Greg Wiegand
 Associate Publisher
 Sams Publishing
 800 East 96th Street
 Indianapolis, IN 46240 USA

Reader Services

Visit our website and register this book at informit.com/register for convenient access to any updates, downloads, or errata that might be available for this book.

Introduction

Welcome to Flickr, the photo- and video-sharing site extraordinaire.

This book covers the ins and outs of Flickr, giving you a guided tour of the Flickr website and what it has to offer you. There are hundreds of Flickr features available to you, and they're all coming up in this book.

What's in This Book

Let's take a look at a quick chapter-by-chapter breakdown of the contents of this book. Here's what you'll find:

- **Lesson 1, "Essential Flickr"**: The essential Flickr story, including how to sign up.

- **Lesson 2, "Uploading Photos"**: All about uploading photos and videos to Flickr—what the limits are, the ways to upload them, even how to upload from cell phones and email.

- **Lesson 3, "Organizing Photos"**: Using the Flickr Organizr, the tool that lets you drag and drop photos and videos to create sets and collections.

- **Lesson 4, "Sharing Photos: Friends, Family, and Contacts"**: All about how to share your photos and videos with others on Flickr. For most people, this is the whole point of Flickr.

- **Lesson 5, "Sharing Photos: Groups"**: All about sharing your photos and videos with Flickr groups.

- **Lesson 6, "Editing Your Photos"**: Flickr partnered with the Picnik editor to let you edit your photos. You can crop, resize, and apply all kinds of visual effects to your photos.

- **Lesson 7, "Working with Video"**: Flickr now supports video and video sharing, and this lesson shows you all the ins and outs.

▶ **Lesson 8, "Favorites, FlickrMail, and Printing"**: Flickr
Favorites is a collection of your favorite photos; Flickr Mail lets
you communicate with other Flickr members; and now you can
use various printing services to print your photos and have them
mailed to you.

▶ **Lesson 9, "Upgrading Your Account"**: Most people have free
Flickr accounts, but you can also upgrade to a paid Flickr Pro
account. This lesson shows all the advantages of doing that.

▶ **Lesson 10, "Troubleshooting and Tips"**: There are plenty of
things that can go wrong when you're working with Flickr. This
lesson is filled with the fix for problems you might experience
and insider tips for new members.

What You Need

This is the good part: You don't need to have anything at all except a
computer with an Internet connection—and some photos you'd like to
store and share on Flickr.

Everything else you need is covered in this book: where to find Flickr,
how to create an account, how to log in, how to use the various parts of
Flickr, and even how to upgrade your account to Flickr Pro.

That's all you need to get started, so let's jump in and do just that in
Lesson 1.

LESSON 1

Essential Flickr

Flickr recently passed three billion photos stored. So, no need to worry that Flickr will run out of images, no matter how many times you refresh the page. Take a look at Figure 1.1, the entrance page to Flickr. This figure shows a random image from Flickr's immense storehouse of images. Welcome to Flickr!

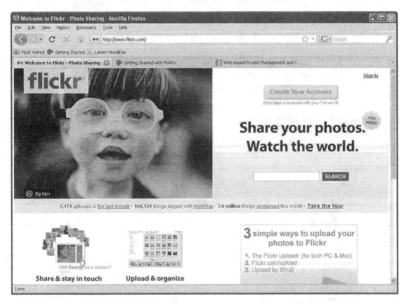

FIGURE 1.1 Flickr's entrance page.

Flickr describes itself this way:

> Flickr is the best way to store, sort, search, and share your photos online. Flickr helps you organize that huge mass of photos you have and offers a way for you and your friends and family to tell stories about them.

Flickr's self-description barely scrapes the surface. Yes, Flickr is a store-house for photos, and you can sort the photos you store on Flickr with ease. But that doesn't get into the true Flickr feeling, which is social. Flickr is really all about sharing your photos as much as it is about managing them, sharing them with friends and family or, if you like, with the whole world—depending on your privacy settings.

You'll find that thousands of people on Flickr are ready to look at and comment on your photos. At root, Flickr invites interaction. You can, of course, use Flickr to back up your photos, and all kinds of snazzy technological perks are available, such as uploading photos directly from your cell phone or having them printed out and sent to you, but the core of Flickr is social. It's all about image *sharing*.

You can get a taste of the sharing aspect of Flickr immediately—no need to have a Flickr account yet. See the search box in Figure 1.1? Type a search term there, such as **dog**, and click the Search button.

You'll be presented with public photos that have been tagged with the word "dog" by the people who uploaded those photos, as you can see in Figure 1.2. Like a photo? Just click it to see a full-size version.

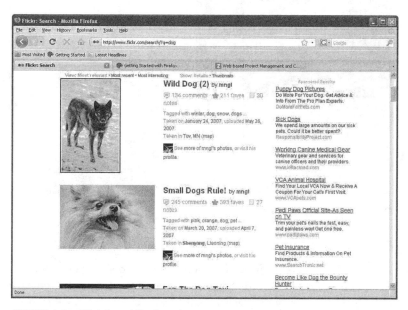

FIGURE 1.2 Flickr's public dog photos.

Already you can get a sense of the sharing ethos of Flickr. Photos like the ones you matched are set to public, and so anyone (with or without a Flickr account) can access them. Note in particular the top photo of wild dogs. That photo has more than 100 comments attached to it. That's one way Flickr members communicate with each other; they comment on each other's photos.

Note also that the photo is marked as being added to some people's Faves collection. You can keep track of your favorite photos this way on Flickr. And as you can see, 20 notes have also been added to the photo. If you'd like to see other photos by the same photographer, you can just click the link at the bottom of the entries. Flickr makes it easy. You can also leave comments on photos, which are general text just about anyone can leave, or notes, which are restricted to the photo's poster and possibly friends and family. (Notes usually give more of the photographer's perspective on photos.)

All of which is to say that Flickr is much more than just a storehouse for images. Through a combination of tagging (which allows you to search for the photos you want), comments, favorites, groups, notes, friends and family privacy settings, and more, Flickr opens a whole community to you.

Flickr is also used increasingly by bloggers, another social contingent on the Web. They use Flickr as a repository for photos they want to include on their blogs.

Let's start our guided tour of Flickr with a brief history, then a quick look at how it works, and then see about signing up for an account so that we can start uploading images.

A Brief History

Flickr was the brainchild of Ludicorp, a small company based in Vancouver, Canada, and was launched in February 2004. (Flickr wasn't meant to be an independent application. Instead, it was part of Ludicorp's application called Game Neverending, a huge online game for multiple players. However, Flickr soon proved popular enough to stand on its own.)

The social aspect of Flickr took the forefront from the beginning. Early versions of Flickr centered on real-time chat sharing. New features have been continually added to Flickr. Many of these features have become very popular, such as groups, which you can join to share a common interest, tagging photos to make them accessible by searches, marking photos as favorites to keep a smaller set of images you like in ready reach, and more.

Flickr's success didn't go unnoticed for long. In March 2005, Yahoo! acquired Flickr (and Ludicorp). In a single week in June 2005, all images were moved from servers in Canada to servers in the United States (which meant, among other things, that the images then became subject to U.S. law).

Flickr's acquisition by Yahoo! has not been without friction, particularly when Flickr started requiring all members, including those who had joined before the acquisition (whom Flickr refers to as Old Skool), to convert their ID to a Yahoo! ID. That caused an uproar for quite some time.

In April 2008, Flickr started allowing paid members (that is, members with Pro accounts) to upload videos (as long as they were less than 90 seconds in playing time and under 150MB). In March 2009, Flickr started allowing the use of high-definition video (which is only available for Pro members, is still subject to the 90-second limit, but can include files of up to 500MB).

The current limits for free accounts are 100MB of photos uploaded a month, plus a maximum of two videos.

Now that you know a bit more about Flickr's past, it's time to take a brief look at how it works, through a cursory overview that will serve as a road map for the rest of the book.

How It Works

Flickr is user friendly. It has lots of features, but you should not feel like you need to memorize how all of them work as you read through this section. Instead, just understand that using Flickr is intuitive and logical, and consider the information in this section as a general walkthrough that will help you follow the discussion throughout the rest of this book.

Uploading

There are numerous ways to upload your images to your Flickr account, including the following:

- ▶ Web interfaces

- ▶ Uploadr

- ▶ Windows/Apple uploads

- ▶ Email

Flickr includes a web interface (with the customary buttons and browse controls) that enables you to upload your images through your browser.

There's also Flickr's application named Uploadr. (You're going to find a bunch of items in Flickr that have lost their final "e", such as Uploadr or Organizr.) Uploadr runs on Macs and on PCs and supports drag-and-drop operation, batch uploading (a big improvement over the web interface), the setting of tags and image descriptions while uploading, and privacy settings.

Printing

Flickr doesn't just allow you to look at pretty pictures. You can also print out images and have them delivered to you. In fact, you have a number of "print" options available. You can order business cards, photo books, stationery, personalized credit cards, and large-size prints (from Flickr partner companies).

Speaking of partners, it's worth noting that Flickr has partnered with Getty Images to sell stock photos from selected members (whom Getty selects).

Organizing

One of the biggest challenges of managing hundreds of images is organizing them. There's great satisfaction to be had in bringing order to a mountain of photos, and that's something Flickr enables you to easily achieve.

In Flickr, the primary way to organize images is via tags (and being able to use tags is one of the chief reasons to put your images on Flickr). Tags hold information about an image, and they can be used as search terms (for example, place names, animal types, geographic names). Adding tags to images is a great way to make them searchable, and searching is one thing computers excel at. By searching your collections of images by tags, you can pull out the specific ones you're looking for immediately. You don't have to flip through several hundred photos individually.

In addition, Flickr enables you to organize your images into sets. A set is a group of images connected in some way (all from the same vacation, for example). A particular photo can be a member of one set or of many sets (or, of course, no set at all).

You can group sets into collections—and collections might themselves be grouped into higher-order collections.

If you don't want to organize and handle your images manually, there's even an extensive Flickr API (application programming interface) that lets you use programming languages like PHP to work with your images— and you can do just about everything using programming code as you can do on the Flickr site itself.

There's even a web application that you can use through your browser to organize your photos: the Organizr. Using the Organizr, you can edit tags and photo descriptions, specify groupings, and even put the photos on a world map (functionality that is offered by Yahoo! Maps). The Organizr lets you select multiple images simultaneously and apply the same changes to all of them. It uses Ajax to mimic the look and feel of a desktop application while, it's making changes remotely to your Flickr account.

Restricting Access

Privacy is a big issue on the Internet, and Flickr responds with access controls available for every image.

The photos you place on Flickr are called your photostream, and you can specify the privacy settings for each image in your photostream. You can set the privacy level for an image (or many images at once) to Private or

Public. Public images can be seen by everyone, whereas private images can be seen only by you. But, that's not the end of the story for private images. You can also allow contacts you've set as friends or family to access your private images.

While you don't have ultimate precision in setting the access to your photos, you can set that access to 1) everyone, 2) no one but yourself, 3) friends, 4) family, or 5) friends and family.

Flickr also supports groups founded to reflect a common interest. Note, however, that if you add images from your photostream to a group pool of photos, the group's access setting takes precedence over your own for those images.

In November 2006, Flickr added support for guest passes, which let you share private photos with nonmembers. For example, you might want to email such a pass to your grandparents to let them see your terrific collection of botanical snapshots.

Filtering

In March 2007, Flickr announced mandatory filtering of all images as Safe or Unsafe. Safe images are those that are unlikely to offend and so suitable for minors. Unsafe images are those that are more likely to offend.

By default, your account is set to Safe. But if you're going to upload images that could offend, it's up to you to classify them as Unsafe. Searching for images by nonmembers or certain members (such as ones whose Yahoo! accounts indicate they're underage) can only be done using a utility named SafeSearch.

Flickr reviews photos uploaded to its site and reclassifies those it deems potentially offensive.

Signing In to Flickr

It all starts when you sign in with Flickr. To sign in to Flickr, you need a Yahoo! ID. (As mentioned previously, Flickr is owned by Yahoo!, so there's no way around that.)

You might already have a Yahoo! ID, in which case signing in is easy (if you remember your ID and password). If you don't have a Yahoo! ID, you need to create one. We take a look at both scenarios here.

If You Already Have a Yahoo! ID

If you already have a Yahoo! ID (that is, you use Yahoo! Mail, Yahoo! Groups, or some other Yahoo! application), signing in to Flickr is easy.

Take a look back at Figure 1.1. See the Sign In link in the upper right? Just click that link to open the sign-in page shown in Figure 1.3.

FIGURE 1.3 The Flickr sign-in page.

On this page, enter your Yahoo! ID and your password, and then click the Sign In button. That's all it takes.

> TIP
>
> Want to avoid signing in every time you want to use Flickr? If so, before you sign in, check the Keep Me Signed In check box shown in Figure 1.3. Checking that check box will keep you signed in for 2 weeks (unless you sign out).

If you know (or suspect) that you have a Yahoo! account but can't remember your ID or password, click the I Can't Access My Account | Help link shown in Figure 1.3. That link takes you to a page with these radio buttons:

- ▶ I Forgot My Password
- ▶ My Password Doesn't Work
- ▶ I Forgot My Yahoo! ID
- ▶ My Account May Have Been Compromised

Select the correct radio button and click Next to get help from Yahoo! to reclaim your ID or password, and then use them to sign in.

Okay, you're in. Flickr will now ask you to create a screen name (the name you'll be known by in Flickr). Let's give the people who don't have a Yahoo! ID the chance in the next section to catch up. (If you have your Yahoo! ID in hand at this point, skip ahead to the "Creating Your Screen Name" section.)

If You Don't Have a Yahoo! ID

If you don't have a Yahoo! ID, creating one is easy. Navigate to Flickr.com and click either the Sign In button shown in Figure 1.1 or the Create Your Account button. Both take you to the same page shown in Figure 1.3.

On the sign-in page, click the Sign Up link in the lower right (see Figure 1.3) to open the Yahoo! sign-up page (see Figure 1.4).

FIGURE 1.4 The top half of the Yahoo! sign-up page.

This is where you create your Yahoo! ID that you will use to sign in to Flickr.

In the Tell Us About Yourself section, enter the following:

▶ First name

▶ Last name

▶ Gender

▶ Birthday (month, day, and year)

▶ The country you live in

▶ Your postal code

In the Select an ID and Password section, complete the following fields:

▶ **Yahoo! ID and Email**: This is the ID you'll be using to sign in to Flickr, so make sure you remember it. (Use 4 to 32 characters, and start with a letter.) Yahoo! IDs look like email addresses, and

by default, they're *xxx*@yahoo.com, but you can select
ymail.com or rocketmail.com from the drop-down list. After
you've entered the ID you want, click the Check button to deter-
mine the availability of that ID. If it's not available, Yahoo! will
tell you so and list some alternatives. If the ID you selected is
available, Yahoo! will replace the two text boxes on this line
with your new ID (displayed as plain text). If you want to
change your ID at that point, click the Change link.

▶ **Password**: Enter the password you want to use (remembering
that capitalization counts). Make it 6 to 32 characters, no spaces,
and don't use your name or Yahoo! ID, (Yahoo! checks for that).
Yahoo! will check the strength of your password (that is, how
guessable it is) and display a green check mark at the end of this
line if it's okay.

▶ **Re-Type Password**: Enter your password again to confirm that
you entered it correctly in both boxes.

In the In Case You Forget Your ID or Password section, Yahoo! wants you
to enter information to make it easy to get your password back to you if
you forget it. So, complete the following fields:

▶ **Alternate Email**: This is the email address Yahoo! will send
your password to if you've lost it.

▶ **1. Security Question**: Select a question from the drop-down list,
such as Where Did You Meet Your Spouse? or What Is the First
Name of Your Favorite Aunt?

▶ **Your Answer**: Enter your answer to the first security question.

▶ **2. Security Question**: Select a question from the drop-down list,
such as Where Did You Meet Your Spouse? or What Is the First
Name of Your Favorite Aunt?

▶ **Your Answer**: Enter your answer to the second security ques-
tion.

Scroll down the sign-up page to the bottom half (see Figure 1.5).

FIGURE 1.5 The bottom half of the Yahoo! sign-up page.

In this part of the page, enter the jumbled visual code into the Type the Code Shown box to verify that you're a person and not a program signing up for a Yahoo! account (as spammers might do). If you can't read the visual code (and that's becoming more and more likely as they seem to be more jumbled over the years), click the Try a New Code button to get a new visual code (and keep clicking the button until you get a code you like).

Then take a look at the Yahoo! terms and conditions by clicking the Yahoo! Terms of Service and Yahoo! Privacy Policy link near the bottom of the page. (To open the terms and conditions in a new page, right-click the link and select Open Link in a New Window from the menu that appears.)

If you accept the terms and conditions, check the Do You Agree? check box.

Finally, if you're satisfied, click the Create My Account button at the bottom of the page.

TIP

The Yahoo! sign-up page times out in 15 minutes, so if it took you longer than that to enter your data, you'll have to do it all over again. Sorry!

If the account creation was successful, you'll see an account summary page, like that in Figure 1.6.

FIGURE 1.6 Successfully creating a Yahoo! account.

To go on to Flickr, click the Continue button.

A page that asks for your password appears, as shown in Figure 1.7.

Flickr periodically asks for your password for security reasons. Enter your password and click the Sign In button.

FIGURE 1.7 The Flickr password page.

Creating Your Screen Name

When you click the Sign In button, as instructed in the preceding section, you will be presented with the screen-name selection page (see Figure 1.8).

Your Flickr screen name is your name as far as Flickr is concerned. It's the name that others will know you by in Flickr, so choose something you won't regret.

FIGURE 1.8 The Flickr screen-name selection page.

Creating Your Profile

After entering your new screen name, click the Create a New Account button, which opens the page you see in Figure 1.9.

This page shows you how to get started in Flickr, and the most important item here is creating your profile.

Your Flickr profile displays the information you want others to have about you on Flickr. Creating that profile is an important part of getting you set up to use Flickr.

TIP

Do you have to create a profile on Flickr? No, if you want to remain anonymous (except for your screen name), you don't have to create a profile.

FIGURE 1.9 How to get started in Flickr.

To create your profile, first click the Personalize Your Profile link (see Figure 1.9), which opens the page shown in Figure 1.10.

The three steps in customizing your Flickr account appear:

- ▶ Create Your Buddy Icon
- ▶ Choose Your Custom Flickr URL
- ▶ Personalize Your Profile

We'll take a look at these in turn, starting with creating your buddy icon, so click the Let's Do It button now.

Create Your Buddy Icon

Clicking the Let's Do It button brings up the page you see in Figure 1.11.

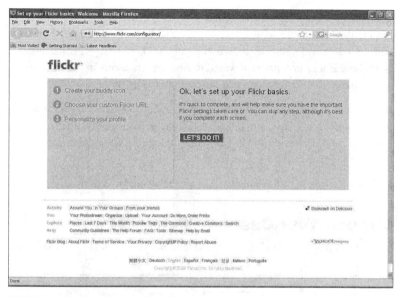

FIGURE 1.10 The Flickr getting started page.

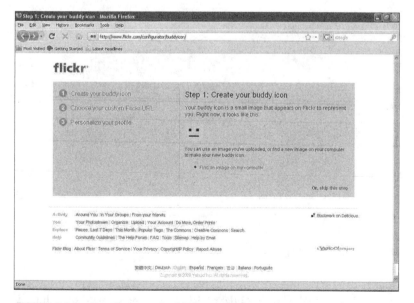

FIGURE 1.11 Creating your buddy icon.

Your buddy icon presents a visual face to other Flickr users, and you can change the buddy icon as often as you like. Right now, it's a gray box with two dots and a line, as shown in Figure 1.11. (This icon is legendary, and whole Flickr groups are devoted to finding situations in nature that mimic the default buddy icon and posting photos of them.)

If you want to load an image from your computer into your buddy icon (because you don't have any images available in your photostream yet), click the Find an Image on My Computer link and follow the directions to browse to and upload your new buddy icon image.

Otherwise, click the Skip This Step link to, obviously, skip this step.

Choose Your Custom Flickr URL

The next step appears in Figure 1.12, which asks you to create a Flickr URL.

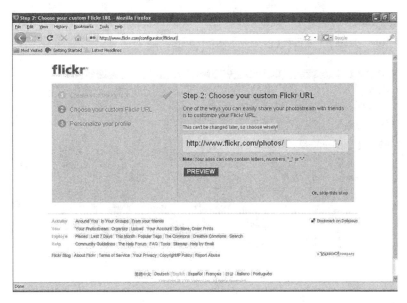

FIGURE 1.12 Creating your Flickr URL.

Your Flickr URL is the URL you'll give to people who want to view your images. If you don't choose a Flickr URL, you'll end up with something ugly like www.flickr.com/photos/43582294259.

> **CAUTION**
>
> It's very important to realize that when you've created your Flickr
> URL, it can't be changed, so choose wisely.

Customize your URL by adding the end part (the www.flickr.com/photos/
part is fixed and can't be changed), and then click the Preview button.

Flickr reloads the page, displaying your Flickr URL in red.

If you're okay with the result, click OK, lock it in, and then click the
Continue button that appears. (If you want to make changes, click the
Wait! I Need to Choose a Different Alias link instead.)

Personalize Your Profile

The next step—the step where you create your Flickr profile—appears in
Figure 1.13.

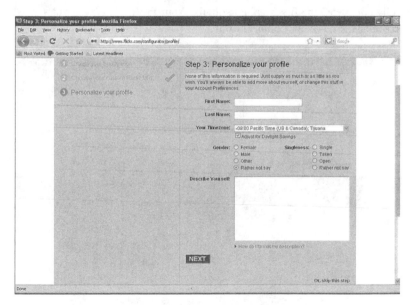

FIGURE 1.13 Creating your Flickr profile.

Complete the following (optional) fields:

- ▶ **First Name**
- ▶ **Last Name**
- ▶ **Your Timezone** (If you want Flickr to adjust your local time for daylight savings time, check the Adjust for Daylight Savings check box.)
- ▶ **Gender**
- ▶ **Singleness** (Select from Single, Taken, Open, or Rather Not Say.)
- ▶ **Describe Yourself** (This is your chance to go wild describing yourself. However, keep in mind who might look you up on Flickr. Your father? Your grandparents? Make sure you won't later regret what you say.)

When you're done with the profile, click the Next button. Doing so brings you back to the startup page (see Figure 1.14). Now that you've successfully completed the first step, Personalize Your Profile is grayed out and a green check mark appears next to it.

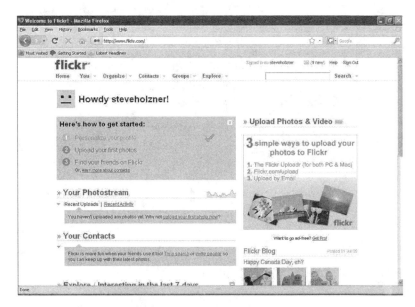

FIGURE 1.14 A Flickr profile successfully created.

The next step is upload your first photos, and that's the subject of Lesson 2, "Uploading Photos."

Summary

In this lesson, you got a brief history of Flickr and a more in-depth overview of how it works. You also learned how to sign up (whether or not you have a Yahoo! account to begin with) and how to create your personal profile.

LESSON 2

Uploading Photos

The whole point of Flickr is to store and share your photos—something you can't do until you first upload your photos to Flickr.

This lesson is all about the uploading process. Here, we're going to get our photos up to Flickr, and in the next lesson, we'll start organizing those photos.

Flickr enables you to upload photos in various ways, including the following:

▶ Using web forms

▶ Using Uploadr

▶ Using email

We'll take a look at each of these methods in this lesson. Which one is right for you? Stay tuned and find out.

Uploading Photos to Flickr

At this point, you should have a free Flickr account and might be wondering how many photos you can upload.

It turns out that there's no limit on the number of photos you can upload; the limit is on the total of all the file sizes you upload each month. For a free account, that can't exceed 100MB per month.

TIP

You can also upload up to two videos a month, as long as they're limited to 90 seconds in playing length and 150MB.

If 100MB isn't enough space for you, you can upgrade to a Flickr Pro account, which, as of this writing, costs $24.95 a year. There is no limit to the number or size of images you can upload to a Pro account.

TIP

Want to sign up for a Pro account? You'll find many links throughout the Flickr site that will let you do just that. For example, you can use the Get a Year of Pro for $24.95 link on your home page (the page that appears when you log in to Flickr). More on Pro accounts is coming up.

There is also a limit on the file sizes that you can upload. If you have a free account, you can upload individual images up to 10MB in size. If you have a Pro account, that's up to 20MB in size. Videos are limited to 150MB in size.

What image types can you upload? There are plenty of image formats floating around the Internet, and Flickr doesn't support them all. Officially, Flickr supports only JPEGs, nonanimated GIFs, and PNGs.

TIP

You can also upload TIFs and some other file types, but note that they will automatically be converted to and stored in JPEG format.

What about file dimensions? Is there a limit? It turns out that Flickr automatically resizes your photos into several sizes it calls "web-friendly:"

▶ 75x75 pixel thumbnail

▶ 100-pixel version (the dimension of the longest side)

- 240-pixel version (the dimension of the longest side)

- 500-pixel version (the dimension of the longest side)

- 1024-pixel version (the dimension of the longest side)

How do you view these various sizes? When you view a photo page, click the All Sizes link below the photo title to view each of the sizes.

What about the original size photo you uploaded? It turns out that the original file is *not* available if you have a free account. The original file that you uploaded (and what many people new to Flickr think is available on the Flickr site) is available only if you have a Pro account.

Okay, now that we've finished with the preliminaries, let's start uploading some photos. First, we'll use the original Flickr way: with web forms.

Using Web Forms

Web forms are those pages that appear in your browser and display all kinds of browser controls such as buttons and list boxes. The original way to upload files to Flickr, and still the default way, is to use a web form.

If you followed the directions in Lesson 1, "Essential Flickr," when you go to Flickr (that is, Flickr.com), you will see the page shown in Figure 2.1.

The page that appears in Figure 2.1 is your Flickr home page (that is, the center of your Flickr activity). Right now, Flickr knows you're just starting out, and so is listing these three steps to get started:

- Personalize Your Profile

- Upload Your First Photos

- Find Your Friends on Flickr

You've completed the first step, Personalize Your Profile, in Lesson 1, and Flickr shows it with a green check mark next to it (see Figure 2.1).

In this lesson, we tackle the second step, Upload Your First Photos. So click that step now, bringing up the page shown in Figure 2.2.

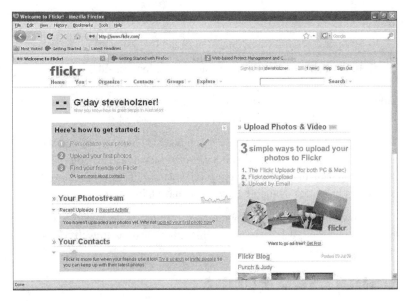

FIGURE 2.1 Your Flickr home page.

FIGURE 2.2 The standard Flickr uploading page.

> TIP
>
> What if your home page doesn't show the three steps you see in Figure 2.1? After you've completed the three steps, they'll disappear. You can always reach the standard uploading form by clicking the Upload Photos & Video link on the home page (and visible in Figure 2.1), or by navigating to www.flickr.com/photos/upload/basic. If you want a quick way to upload an image, click the You link in the home page, and the page that opens will let you upload a single image (but not set tags or privacy for the image).

The Standard Form

The form you see in Figure 2.2 is the standard Flickr uploading form. Note that on the left it keeps track of the fraction of your monthly upload capacity that you've used. Here, that's 0% because we haven't uploaded anything yet.

The standard form is a good one, and it has served Flickr for a long time, but it's somewhat limited. You can upload only up to six images at one time, as you can see in Figure 2.2, and you have to browse to each one separately (no drag and drop). You can add tags only to the whole batch en masse.

The standard form has four sections:

- ▶ Specify the Images
- ▶ Set the Tags
- ▶ Specify the Privacy Setting
- ▶ Advanced Options

In the first section, you specify the images you want to upload. Suppose you've decided to upload some images from your recent Hawaii vacation. Just follow these steps:

1. Click a Browse button. This causes your browser to display a File Upload dialog box (see Figure 2.3).

FIGURE 2.3 A browser File Upload dialog box.

 2. Double-click the image you want to upload. That makes your
 browser close the dialog box, and the filename will appear in the
 text box next to the Browse button.

The second section of the standard form lets you associate tags with the
images en masse. You can't specify individual tags here.

Tags are used to make photos searchable on Flickr. You can search for
images by tag. In the Add Tags to the Whole Batch? text field, list any
tags you want to connect to the images. For example, you might use the
tag Hawaii for your Hawaii images.

If you have a tag that's made up of two words or more, surround that tag in
double quotation marks (like "Hawaii Beach"). You might also note that
Flickr automatically strips out words such as "and" or "the" from tags.

The third section of standard upload form lets you set the privacy of your
images with these controls:

 ▶ **Private** (only you see them)

 Visible to Friends

Visible to Family

▶ **Public** (anyone can see them)

The default privacy for your uploaded photos is Public (this item's radio button is selected), which means no privacy at all; anyone can see the images.

If you want to make your images more private, click the Private radio button. If you leave just that radio button clicked, only you can see the images. To expand that to people you've listed as friends or family (see the next lesson), check the check boxes in front of the friends or family items.

The fourth section in the standard upload form is the Advanced Options section. Click Show Advanced Settings to display these options, and you'll see a heading followed by three check boxes:

▶ **Set Safety Level**

Safe (your default)

Moderate

Restricted

The safety level is the suitability of your images and video, and the default is Safe (that is, safe for viewing by minors). You can also set the safety level to Moderate or Restricted (not suitable for minors). Under the Flickr community guidelines, you're responsible for setting your content's safety level.

CAUTION

Restricted video content isn't permitted on Flickr. Only safe or moderate videos can be uploaded and shared. If you upload restricted video under a different safety setting, your account will be terminated.

The Advanced Options section also lets you set the content type of the upload to one of three settings:

▶ **Set Content Type**

Photos / Videos (your default)

Screenshots

Art, Illustration, CGI, or Other Non-Photographic Images

And finally, you can block your upload from public searches with the advanced options by clicking the Yes check box:

▶ **Hide These Images from Public Searches?**

Yes

When you've filled out the standard upload form to your satisfaction, click the Upload button at the bottom of the form. Your images will be uploaded, and you'll see the page that appears in Figure 2.4, where you can configure your upload.

FIGURE 2.4 Configuring an upload.

The top two boxes let you perform batch operations—connect the same tags to all images in the upload and add the upload to a set. We haven't created any sets yet (that's coming up in the next lesson), so skip down to work with the individual images in this upload.

For each uploaded image, you can set its:

▶ Title

▶ Description

▶ Tags

Each Flickr image usually has all three of these items set. The title is just what it sounds like: a title for the image (which appears above the image in your photostream). The description gives more information about the image, and now you can set tags on an image-by-image basis.

Fill out the Title, Description, and Tags boxes for each image in your upload and click the Save button at the bottom of the page. When you do, the uploaded images are added to your photostream, which appears in your browser, as shown in Figure 2.5. Success! You've uploaded your first images.

FIGURE 2.5 Your new photostream.

Flickr acknowledges that you've uploaded your first photos. Take a look at your home page (click the Home link at the top of any Flickr page), and you'll see that Flickr has checked off the Upload Your First Photos item in its Getting Started list, as shown in Figure 2.6.

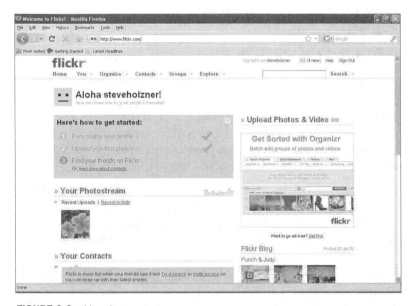

FIGURE 2.6 Your home page.

Now you've uploaded your first images. Not bad!

> TIP
>
> To move back to your photostream from your home page, click the Your Photostream link on the home page.

That's how to upload images using the standard form—still the way that most people upload to Flickr. But there's a new form, too, so let's take a look at it next.

The New Flash Form

If you've got the latest Flash player installed (and JavaScript is enabled on your browser), you can use Flickr's new Flash-based form for uploading.

Just go to your home page (Flickr.com and log in if Flickr doesn't log you in automatically), and click the Upload Photos & Video link, which brings up the Flash-based form you see in Figure 2.7.

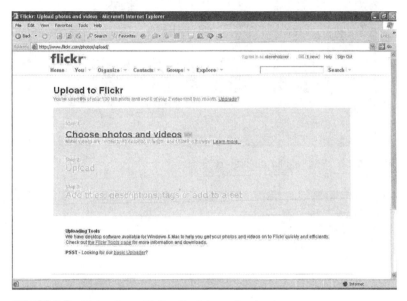

FIGURE 2.7 Uploading with the Flash-based uploader.

Click the Choose Photos and Videos link to open an upload dialog, as shown in Figure 2.8. (This dialog box will look different depending on which browser you're using.)

If you just want to upload one photo, double-click that photo. If you want to upload multiple photos, hold down the Ctrl key (Mac users substitute the Command key), click the photos you want to select (or hold down the Shift key to upload a range), and then click the Open button.

The Flash uploader displays a list of the photos you've selected, as shown in Figure 2.9.

FIGURE 2.8 The upload dialog box.

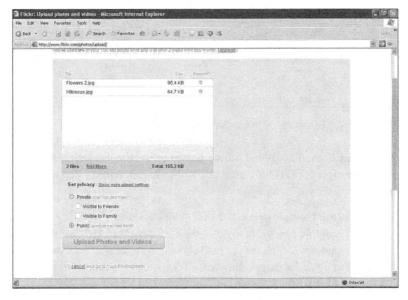

FIGURE 2.9 A list of photos to upload.

By default, the Flash version lets you set the privacy level of only the photos you're uploading, as you can see in Figure 2.9. To see more options, click the Show More Upload Settings link, and you'll get these options:

▶ **Set Privacy**

 Private (only you see them)

 Visible to Friends

 Visible to Family

 Public (anyone can see them)

▶ **Set Safety Level**

 Safe (your default)

 Moderate

 Restricted

▶ **Set Content Type**

 Photos / Videos (your default)

 Screenshots

 Art, Illustration, CGI, or Other Non-Photographic Images

▶ **Hide These Images from Public Searches?**

 Yes

After you've set the options for all the photos you're uploading, click the Upload Photos and Videos button. That uploads the photos and displays the message "Finished! Next: Add a Description, Perhaps?"

Click the words Add A Description to see a new page (the same as shown in Figure 2.4), which lets you add descriptions, titles, and tags for all uploaded photos.

After entering the descriptions, tags, and titles for your photos, click the Save button at the bottom of the page.

When you click the Save button, Flickr takes you to your photostream page, and you can see the newly uploaded photos as part of your photostream, complete with tags, descriptions, and titles.

As you can see, the Flash uploader is just like the standard uploader—just a little slicker.

Using Flickr Uploadr

Flickr also has desktop software that you can use: the Flickr Uploadr.

To give the Uploadr a try, go to the Upload page (from your home page, click the Upload Photos & Video link). Then search for this text:

> We have desktop software available for Windows & Mac to help you get your photos and videos on to Flickr quickly and efficiently. Check out the Flickr Tools page for more information and downloads.

Click the Flickr Tools link to open that page in your browser. On the Tools page, look for the heading Desktop Uploadr, and find these two links under that heading:

- ▶ Windows Vista & XP: Download (12MB)
- ▶ Mac OS X 10.5 & 10.4: Download (20MB)

Click the link for your operating system. Your browser will display a dialog box. Click the Save button and save the Uploadr download to your hard disk. When the download is complete, click the Run button.

Clicking the Run button launches the Uploadr installation program, as you can see in Figure 2.10.

To install Uploadr, follow these steps (for the Windows version):

1. Click the Next button.

2. Select a location to install Uploadr to and click Next. The location of Uploadr isn't important; you can accept the default location selected by the installer.

3. On the next page, if you want a desktop shortcut icon for
Uploadr to make it easy to launch, leave the Create Desktop
Icon check box checked and click Install.

4. After installation is complete, click Finish.

FIGURE 2.10 Installing Uploadr.

Double-click the new desktop icon for Uploadr to run it, as you see in
Figure 2.11.

The first step is to sign in to Flickr.

Signing In to Flickr

To upload your photos, you need to be signed in to Flickr, so click the
Sign In button in Uploadr.

To sign in to Flickr, follow these steps:

1. Uploadr will display a dialog box explaining that you have to
sign in to Flickr. Click OK.

2. This starts your browser. Find the text "If you arrived at this page because you specifically asked Flickr Uploadr to connect to your Flickr account, click here." Click the Next button underneath that text.

3. Flickr next displays this text:

 By authorizing this link, you'll allow Flickr Uploadr to:

 ▶ Access your Flickr account (including private content)

 ▶ Upload, Edit, and Replace photos and videos in your account

 ▶ Interact with other members' photos and videos (comment, add notes, favorite)

 Click the OK, I'll Authorize It button.

4. The next window in your browser has this message: "You have successfully authorized the application Flickr Uploadr." Close the browser window.

5. Go back to Flickr Uploadr and click the Ready! button.

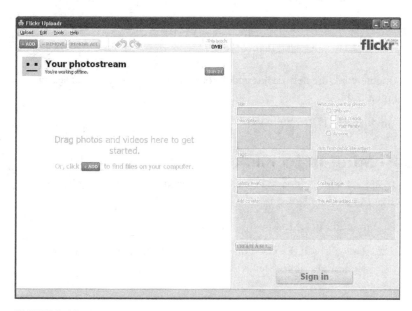

FIGURE 2.11 Running Uploadr.

Uploading to Flickr

Now you're ready to use Uploadr. The easiest way is to drag photos into Uploadr.

For example, in Windows, open Windows Explorer and navigate to the photo you want to upload. Then drag that photo or photos onto the text "Drag photos and videos here to get started" in Uploadr. Doing so displays the dragged photo in Uploadr, as shown in Figure 2.12.

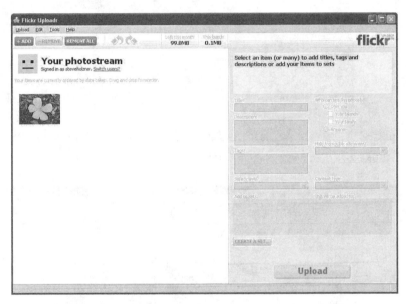

FIGURE 2.12 A new photo in Uploadr.

Select the photos you want to add information to, and enter the titles, descriptions, and tags.

Then click the Upload button. After the uploading process is finished, you'll see a dialog box with this message: "Your upload is complete." Click the Go to Flickr button to open the description page shown in Figure 2.13.

On this page, you get the chance to edit a photo's title, description, and tags. After making any edits you want, click the Save button. Your newly uploaded photo appears in your photostream, as shown in Figure 2.14.

FIGURE 2.13 Editing a photo's settings.

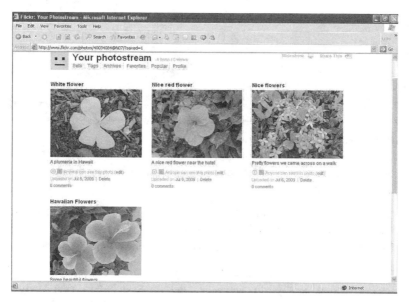

FIGURE 2.14 A new photo in your photostream.

Cool. Now you've uploaded a new photo (or photos) using Flickr Uploadr.

Now let's upload using email.

Using Email to Upload Photos

Flickr assigned everyone a unique email address that you can use to upload photos. That's great not only for emailing photos from your desktop, but from your cell phone as well.

To find your unique email address, go to www.flickr.com/account/uploadbyemail/. You can see this page in Figure 2.15; your email address will appear at the upper right.

FIGURE 2.15 Emailing instructions.

To email photos to your photostream, you attach the photos to the email you send to your unique email address.

What about the titles, descriptions, and tags? The email's subject becomes the title, the body becomes the description, and any words you place after "tags:" in the body become the tags. For example:

Subject: Squirrels

Body: We put out some peanuts and about a dozen squirrels showed up.

Tags: peanuts "cute squirrels"

For example, you might decide to upload a photo of Waikiki Beach from your Hawaii vacation to your photostream via email—and you can see the new photo in the photostream in Figure 2.16.

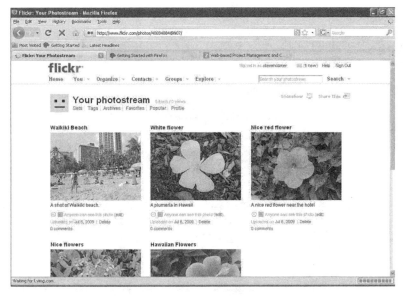

FIGURE 2.16 An emailed photo of Waikiki Beach.

Now you're able to upload photos directly using email.

> TIP
>
> Want to post photos from Flickr to your blog via email? You'll find the directions at www.flickr.com/account/uploadbyemail/blog/.

Summary

This lesson covered how to upload photos to Flickr. There are three primary ways: using the uploading form (either the standard or the new Flash version), using the Uploadr dedicated software, and emailing your photos to Flickr. This lesson covered them all.

LESSON 3

Organizing Photos

There's more to creating a photostream than just uploading a pile of photos. When you've got a pile of photos, you don't have much organization—just a lot of photos, some related, some not.

Flickr lets you take your piles of photos and organize them for easier access. You can create sets of photos and organize your photos by adding them to the sets. If you're a Pro user, you can also create collections—that is, collections of sets—and you can also create maps of photos.

We'll take a look at bringing order to the chaos of a mass of photos in this lesson. Then in the next lesson, you'll learn how to share some of your organized photos with others.

Introducing the Organizr

The handy Flickr tool for organizing your photos is called the Organizr. (Surprised?)

The Organizr lets you create photo sets and add photos to them; and if you're a Pro user, you can also create collections of sets with the Organizr tool.

Let's take a look at the Organizr. You can access it easily from any Flickr page by clicking the Organize link that appears on all Flickr pages. For example, go to your home page at Flickr.com, as shown in Figure 3.1.

Note the Organize link in the link bar just below the Flickr logo in the upper left of the page. You'll find that link on every Flickr page, and it brings up the Organizr.

Click the Organize link now to display the Organizr (see Figure 3.2).

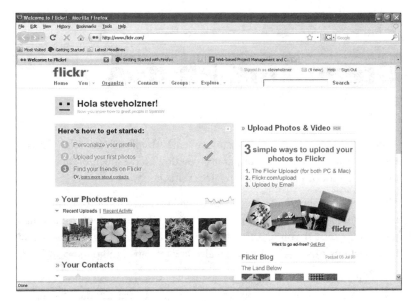

FIGURE 3.1 Your Flickr home page.

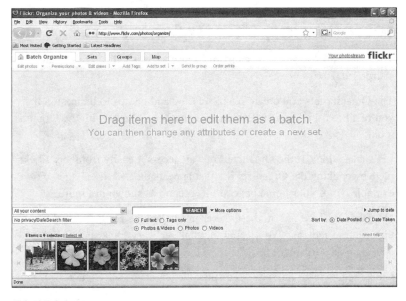

FIGURE 3.2 The Organizr.

Note the tabs at the top of Organizr:

▶ **Batch Organize**: Lets you group photos together to work on them en masse. Drag and drop photos here to batch them together.

▶ **Sets** (**Sets & Collections** for Pro accounts): Lets you create and manage sets of photos (and collections of sets if you're a Pro user).

▶ **Groups**: Lets you manage the groups you're sharing your photos with.

▶ **Map**: Lets you organize your photos geographically.

The middle section of the Organizr is the workspace, and you can drag and drop photos here to create batches of photos that you can edit en masse.

One of the first things you notice in the Organizr is the list of photos in the strip at the bottom. That's the Findr, which lets you select the photos you want to work with in the Organizr.

To select photos in Findr, you have the following options:

▶ To select one photo, just click it.

▶ To select a number of photos, hold down the Ctrl key (Command key for Mac users) and click the photos.

▶ To select a range of photos, click the first one in the range, hold down the Shift key, and click the last on in the range.

Let's start by creating a batch of photos so we can work with a group of photos simultaneously.

Creating Batches

Suppose you want to create a set of red flower photos from your vacation. The first step in doing that is to create a batch of the photos you want to group together. A batch is just a group of photos in the Batch Organize workspace (the middle section of Organizr).

To create a batch, you can drag photos, either singly or in groups, from Findr to the Organizr workspace. There are multiple ways of searching for photos using Findr, so let's get an overview now.

Finding Photos in Findr

To see all the search options in Findr, click the More Options link at the top of Findr, which shows all the options visible in Figure 3.2.

The first drop-down list lets you specify what selections you want visible in Findr. Here are the choices:

- ▶ All Your Content
- ▶ Your Non-Tagged Content
- ▶ Your Content Not in a Set
- ▶ Your Geotagged Content
- ▶ Your Non-Geotagged Content
- ▶ Content Uploaded On

 July 6, 2009 (for example)

 July 3, 2009 (for example)

Below this drop-down list, you can specify the privacy settings of the photos that Findr will show. Here are those settings:

- ▶ No Privacy/SafeSearch Filter
- ▶ Only Show Public Content
- ▶ Only Show Content Visible to Friends

- ▶ Only Show Content Visible to Family

- ▶ Only Show Content Visible to Friends & Family

- ▶ Only Show Private Content

- ▶ Only Show Safe Content

- ▶ Only Show Moderate Content

- ▶ Only Show Restricted Content

Next to the two list boxes is a search box, which makes it easy to search through your photostream for photos with a specific tag or specific keywords in the description text. That means you can easily assemble all photos of your Aunt Minnie into the same batch.

Beneath the search box are the two radio buttons you use to specify what text to search: Full Text (which includes tags) or Tags Only.

To the left of the two radio buttons are the date controls. You can find photos with a specific date by clicking the Jump to Date link, or sort by either the date you uploaded the photos or the date they were taken with the Sort By: Date Posted and Date Taken radio buttons.

Finally in Findr, you can specify that you want to search through photos/videos with the Photos & Videos, Photos, and Videos radio buttons.

After setting the search options you want, the matching photos/videos will appear in Findr. The next step is to drag them to the Organizr workspace.

Dragging Selections to Organizr

Now that the photos you want appear in Findr, select them and drag them—either singly or multiply—to the workspace of the Organizr (in particular, the Batch Organize tab).

Figure 3.3 shows the results; the photos you've selected appear in the Organizr.

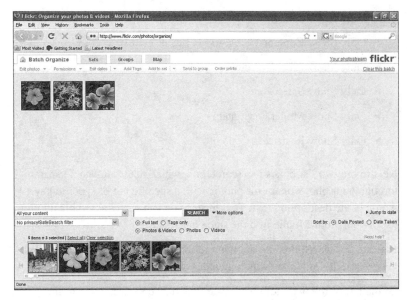

FIGURE 3.3 Creating a batch.

You've now created a batch of photos and can work on them en masse. What can you do? You can edit the photos (including their titles, tags, and descriptions), set their permissions, add tags, and more.

The actions you can take are reflected in the links at the top of the Batch Organize tab:

▶ Edit Photos

 Titles, Tags, and Descriptions

 Rotate

 Delete

▶ Permissions

 Who Can See, Comment, Tag?

 Change Licensing

 Set Safety Filter

Set Content Type

Hide/Show in Public Searches

► Edit Dates

► Add Tags

► Add to Set

New Set

Existing Set

► Send to Group

► Location

► Order Prints

For example, say you wanted to add a tag or tags to all the photos in your batch. You'd do that by clicking the Add Tags link, which opens the dialog box you see in Figure 3.4.

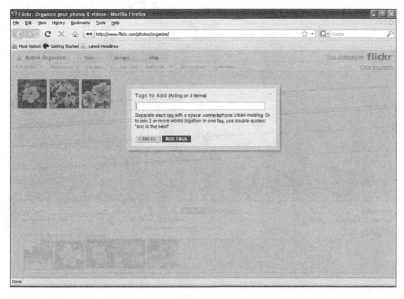

FIGURE 3.4　Adding tags.

To add a tag to all photos in the batch, just enter the new tags (enter multiple tags separated by a space, and enclose multiword tags in double quotation marks) and click the Add Tags button. Voilà, it's as easy as that to work on photos en masse.

Okay, now let's see how to create a set of photos.

Creating Sets

Suppose you want to group a number of photos into a Flickr set (for example, a set of red flower photos).

To get started, click the Sets tab in Organizr to open the tab shown in Figure 3.5.

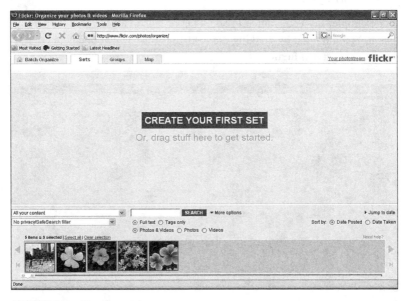

FIGURE 3.5 The Sets tab.

Doing so creates a new set in a new tab, as you can see in Figure 3.6.

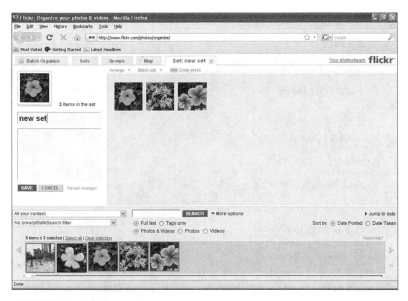

FIGURE 3.6 A new set.

You can see the set options at the top of the tab page:

▶ **Arrange**

Arrange by Date Taken (Oldest First)

Arrange by Date Taken (Newest First)

Arrange by Date Uploaded (Oldest First)

Arrange by Date Uploaded (Newest First)

Alphabetically

Randomly

Reverse Current Order

▶ **Batch Edit**

Titles, Tags, and Descriptions

Change Permissions

Change Licensing

Set Safety Filter

Set Content Type Hide/Show in Public Searches

Add Tags

Change Dates to Same Day

Time Shift Dates

Rotate

Send to Group

Change Geoprivacy

Add Items to the Map

Remove Items from the Map

Delete This Set

▶ **New Order Prints**

The two text boxes on the left hold the set's title and description. You can add your own name and description, as shown in Figure 3.7.

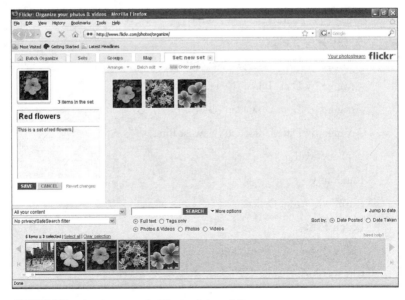

FIGURE 3.7 Setting a set's title and description.

To save the set, click the Save button. When you do, the set closes, and it's represented by one of the photos in the set (see Figure 3.8).

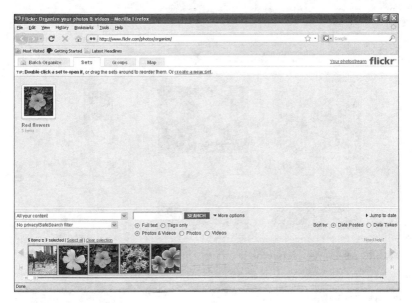

FIGURE 3.8 A closed set.

The new set appears in your photostream, as you can see in Figure 3.9.

To open the set from your photostream, double-click it. The set opens, as shown in Figure 3.10.

Editing a Set

Editing a set is easy with Organizr. Just click the Organize link in any Flickr page, click the Sets tab, and double-click the set you want to edit, opening that set for editing, as shown in Figure 3.11.

FIGURE 3.9 A new set in the photostream.

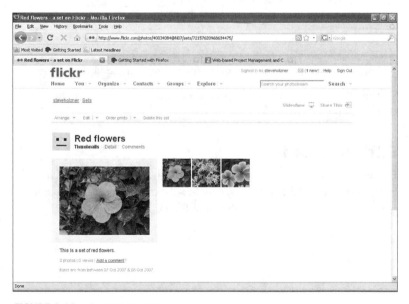

FIGURE 3.10 Opening a set.

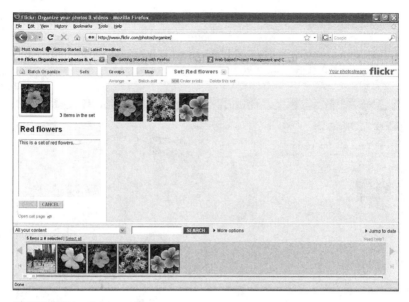

FIGURE 3.11 Editing a set.

To add a new image to the set, drag that new image from the Findr bar to the set.

To delete an image from the set, drag the image to the Findr bar and release it. That doesn't delete the actual image; it just deletes the image from the set.

You can use the menus in the Organizr to edit the set as well. The Arrange menu lets you arrange photos by date or name and so on, and the Batch Edit menu lets you edit all the set photos' titles, descriptions, and tags simultaneously.

Want to create a new set? Click the Set tab, and then click the Create a New Set link.

You can even specify what set you want photos and/or videos added to when you upload them with Uploadr.

Take a look at Figure 3.12, for example. That's Uploadr preparing to upload an image for us. Note that at bottom right, it's got a heading Add to Sets, and underneath, our Red Flowers set is listed—Uploadr knows all about our set already.

FIGURE 3.12 Specifying a set with Uploadr.

To add the photos and/or videos you're uploading to a set, select that set in Uploadr before uploading them. Easy.

Setting a Set's Image

All sets are represented by one of the photos in the set. As you can see in Figure 3.11, one of the red flowers stands for the whole set when the set is closed.

You might want to substitute the photo that Flickr chose to represent the set.

Doing that is easy: Just click the Sets tab, and then double-click the set you want to work on to open it in its own tab. You'll see all the photos in the set lined up, available for you to work with.

The image that Flickr uses to represent the set is larger than the other images, and it's off to the left. To use another photo instead, drag that photo over the image that Flickr uses to represent the set, as shown in Figure 3.13.

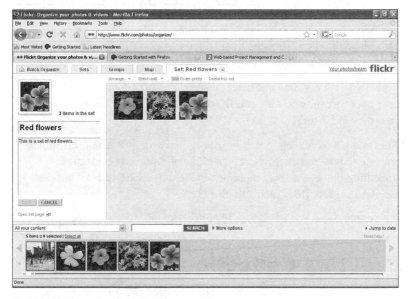

FIGURE 3.13 Changing the image that represents a set.

When you're satisfied with the photo that will represent the set, click the Save button. Flickr will close the set, and the set will be represented by the new photo from now on.

Who Can See the Photos in a Set?

The photos in a set work just like any Flickr photos—each has its own set of permissions, and the people who can see those photos are the people you've given permission to. For example, everyone can see the public photos in a set. But if you've marked some photos as private, not even for friends or family, then only you can see those photos. The photos you've marked for friends and family can be seen by those groups.

> **TIP**
>
> Bear in mind that if you share a set with a group (groups are discussed starting in the next lesson), the group's permission settings supersede your own for those photos—with possibly unintended results.

Sets are great to let you create "minialbums" in Flickr. You can organize your photos into sets showing your business trip to San Francisco, your Arctic expedition, or your family barbeque.

Organizing your photos into sets is a great idea because then visitors to your photostream won't have to sift through all your photos to find the ones they came for.

Note that if you're a big-time Flickr user, however, just using sets might not be enough. You might want an additional level of organization—something that can display multiple sets, letting others select which set they want to see. Does such a thing exist?

It certainly does! You can create Flickr collections.

Creating Collections

What's the difference between a set and a collection? As you've seen, a set holds a number of photos or videos. A collection can hold a number of sets.

That's good when you have a hierarchy of photos. For example, you might have been on a big expedition to the American West and want to list each day's photos in a separate set. In that case, you might create a collection of each day's photo sets so you have all your Wild West photos in one collection.

Or you might have a real estate portfolio that you want to showcase for sale, perhaps a dozen properties. Each of those properties could become a photo set in the overall collection, which would represent your total portfolio.

Sound good?

It might—until you learn that to create a collection, you have to be a Flickr Pro user.

Yes, collections can only be created by Pro users. For that reason, we'll take a look at how to work with collections when we discuss Pro accounts in Lesson 9, "Upgrading Your Account."

We'll also preview creating collections here. After all, if they appeal to you, creating your own collections might be the reason you want to sign up for Flickr Pro.

Creating a collection is not hard. Just follow these steps:

1. Click the Organize link in any Flickr page to open the Organizr.

2. Click the Sets & Collections tab. In that tab, you'll see a link to create a new collection.

3. Click that link, and give your new collection a title and description. You'll see the available sets on the same page. Drag the sets you want to add into your new collection.

4. After you've added your sets, click the Create Mosaic button. Sets are represented by a single photo from the set, but collections are represented by a mosaic of images from the collection.

 When you click the Create Mosaic button, Flickr will randomly select photos from your collection to add to the mosaic.

 Flickr selects the photos it adds to the mosaic randomly with a strong preference for public photos. (In fact, if there is only one public photo in your collection, Flickr will use that photo, and only that photo, for the mosaic.) You can override what image appears in the mosaic by simply dragging your own photos there.

TIP

Here's an oddball fact: The private photos in a collection aren't visible to people who don't have permission to see them, but the private images that are used in the collection's mosaic (if any) are.

If you're a Pro user, you can create as many collections as you like. You can even create collections of collections—but there's a limit on that. You can only add collections five levels deep.

Adding Photos to Maps

There's something else you can do to organize your photos on Flickr: You can *geotag* them by positioning them on Flickr's global map.

What does that mean? It means you can drag and drop your photos on a map, which will store their location. Then when someone looks at your photos in your photostream, a small Map link will appear by the photos that have been geotagged. Clicking that link opens a map that shows where the photo was taken (and the map also shows the location of other Flickr photos that have been geotagged nearby to help foster a sense of community).

This is a great feature for travelogues, vacations, or expeditions of any kind, and it allows people to see exactly where a specific photo was taken along, say, your trek to the South Pole.

To get started, open Organizr (click the Organize link in any Flickr page), and then click the Map tab in Organizr.

The first time you open the Map tab, Flickr will display a warning dialog box, asking you to specify who can see the location of your photos, as shown in Figure 3.14.

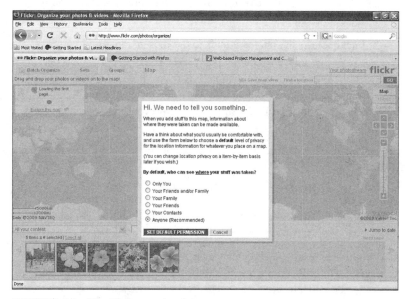

FIGURE 3.14 The Flickr warning for maps.

If you're worried about cyberstalkers, you might want to restrict who can see the geotagging of your photos. Here are the choices for restricting that information, as given in the dialog box:

▶ Only You

▶ Your Friends and/or Family

▶ Your Family

▶ Your Friends

▶ Your Contacts

▶ Anyone (Recommended)

Make your selection in this dialog box (Anyone is selected by default) and click the Set Default Permission button. A confirmation dialog box appears, so click OK to dismiss that box.

Now the map itself appears in Organizr, as shown in Figure 3.15.

FIGURE 3.15 The Organizr map tab.

You can use the zoom bar on the right to zoom in on the part of the world you want to see, as shown in Figure 3.16.

FIGURE 3.16 Zooming in on the map.

When you're sufficiently zoomed in, you can drag photos from the Findr to the map and drop them where you want them, as shown in Figure 3.17.

> **CAUTION**
>
> If you drop a photo on a map and haven't sufficiently zoomed in so that Flickr can accurately gauge the photo's location, Flickr will display a dialog box asking you to zoom in some more. You don't have to accept that advice, but if you don't, people won't be able to locate your photos on the map.

Where does the map information show up? That is, how can people see it? When you geotag a photo, a Map link appears in that photo's photostream entry, as shown in Figure 3.18.

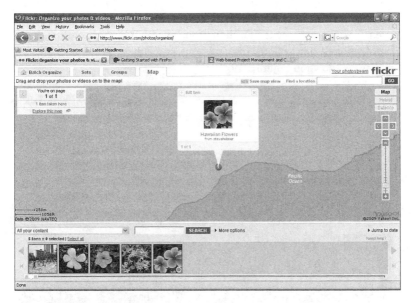

FIGURE 3.17 Dropping a photo on a map.

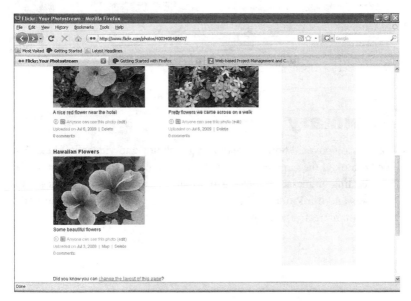

FIGURE 3.18 A Map link has been added to the photostream entry.

When you click the Map link for a geotagged photo, the global map opens, and you can see the location of the photo on the map—along with the location of other photos from other users that have been geotagged nearby, as shown in Figure 3.19.

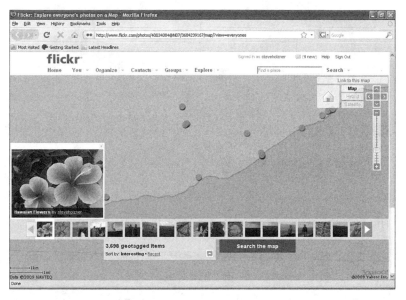

FIGURE 3.19 Opening a photo's map.

Summary

This lesson covered how to organize your photos and videos in Flickr. We took a look at the Organizr, which allows you to batch photos together for easy editing en masse. You can also use the Organizr to group your photos into sets and, for Pro users, collections. Finally, you can locate your photos on an interactive map by geotagging them.

Sharing Photos: Friends, Family, and Contacts

Now that you've uploaded your photos and videos, it's time to do what Flickr excels at: sharing those photos and videos with others.

That's what Flickr is all about. Unless you're using Flickr only to back up your photos, the whole idea behind Flickr is to share your photos. This lesson focuses on sharing photos with the contacts you make on Flickr. You can divide your contacts into friends and family and set your photos to be visible by both sets of people.

The next lesson will be all about the other way to share photos on Flickr: groups. Groups are formed on Flickr around common interests, and groups can also engage in discussions and share photos.

Flickr Is a Social World

The whole inspiration behind Flickr is social. Yes, it's a site that lets you store your photos and videos online, but if that were the end of it, Flickr would be a very small site indeed.

Instead, Flickr provides you with a way to share photos and videos with your friends and family, no matter where they are located. You could do things the old way, and have copies made of all your photos and laboriously send them out to various people through the mail.

Or you could simply post your photos and videos on Flickr and then tell your friends and family about them, inviting them to take a look.

Besides your own friends and family, Flickr is a terrific place to make new friends. You can search Flickr for photos and videos you're interested in and leave comments about those photos and videos. You can even add the people who took those photos and videos as friends on Flickr.

All of which is to say that Flickr is a social place, and you should take advantage of that.

Searching Flickr for Photos

Flickr is all about sharing photos, and there are tons of ways of finding photos on Flickr. Let's take a look at a few of them.

Exploring Flickr

If you're just getting into Flickr, the Explore page is a good place to start. The Flickr staff routinely browses photos that members have uploaded and labeled Public and posts the most interesting ones on the Explore page.

You can find the Explore page by clicking the Explore link that appears on every Flickr page or by navigating your browser to www.flickr.com/explore/, as shown in Figure 4.1.

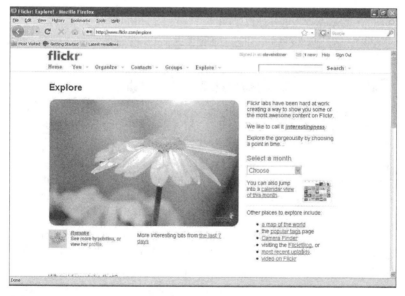

FIGURE 4.1 The Flickr Explore page.

Want to see another Explore photo? Just reload the page, and it'll cycle through all the photos the Flickr staff has recently labeled as interesting.

Exploring the Most Recent Photos

Flickr also presents a list of photos that always stays fresh: the Most Recent Photos and Videos list. This list displays the most recently uploaded photos.

You can see the Most Recent Photos and Videos at www.flickr.com/photos/, as shown in Figure 4.2.

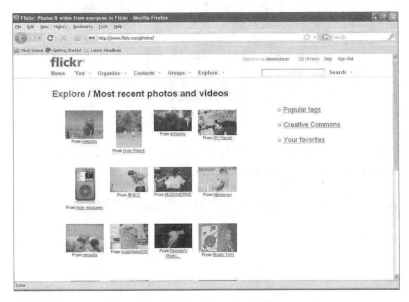

FIGURE 4.2 The Flickr Most Recent Photos and Videos page.

The thumbnails on the Most Recent Photos and Videos page are hard to make out. To see the whole photo, click its thumbnail, opening the photo in its own page, as shown in Figure 4.3.

As you know, Flickr stores photos in various sizes. If you want to see the full photo with its larger dimension set to 1024 pixels, click the All Sized link you see above the photo in Figure 4.3. Doing so opens the large version of the photo shown in Figure 4.4.

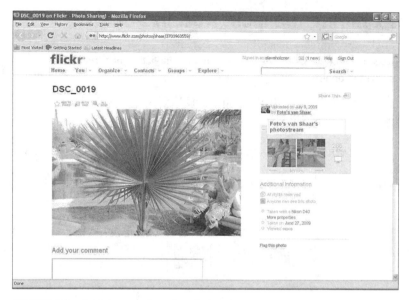

FIGURE 4.3 A bigger version of a photo.

FIGURE 4.4 All versions of a photo.

The other image sizes are provided with links; click a link to see the photo in that size. For example, here are the sizes for the image shown in Figure 4.4:

- ▶ Square (75x75)

- ▶ Thumbnail (100x67)

- ▶ Small (240x160)

- ▶ Medium (500x333)

- ▶ Large (1024x681)

- ▶ Original (3008x2000)

> **TIP**
>
> The photo in its original size is available only for photos stored in Pro accounts.

Another popular Explore page is the most interesting photos of the last 7 days, which you can find at www.flickr.com/explore/interesting/7days/ (see Figure 4.5).

These photos are selected by the Flickr staff.

> **TIP**
>
> You can also take a look at the current photo that the Flickr staff considers has the most "interestingness" at www.flickr.com/explore/interesting/.

Searching by Tag

You can also explore all the public photos on Flickr by tag. To do so, use the search box you find at the upper right on most Flickr pages, such as in Figure 4.6.

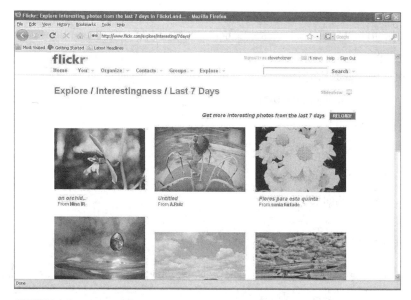

FIGURE 4.5 The most interesting photos of the last 7 days.

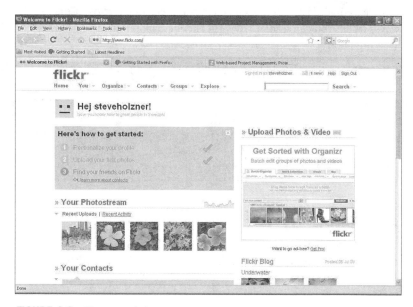

FIGURE 4.6 The search box.

You can select how to search by clicking the drop-down arrow to the right of the search box and selecting from these options:

- ▶ Everyone's Uploads (the default)
- ▶ From Your Contacts
- ▶ From Your Friends
- ▶ Your Photostream
- ▶ Groups
- ▶ Flickr Members
- ▶ For a Location

For example, suppose that you're remembering fondly your most recent trip to Europe and want to search for photos of Austria. Type **Austria** into the search box and press Enter, which yields the results you see in Figure 4.7.

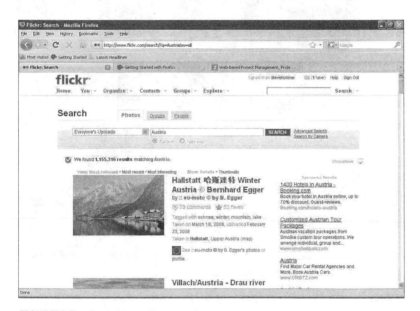

FIGURE 4.7 Search results.

> TIP
>
> Want to find out what tags are the hottest in terms of searches? Go to Hot Tags: www.flickr.com/photos/tags/. Want to search by geotagged location? Select For a Location in the search box before performing your search.

Adding Comments

Say that you've found a photo you like, such as the one in Figure 4.8.

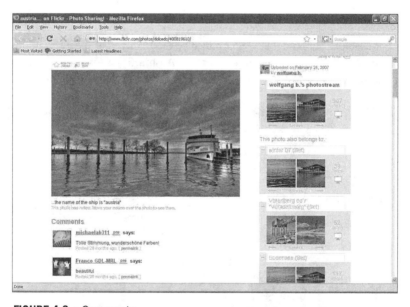

FIGURE 4.8 Comments.

Note the comments that appear under the photo, each showing the commenter's buddy icon and comment text.

Flickr comments are an integral part of the sharing process. Comments are Flickr's way of letting others create minidiscussions about photos. Leaving and reading comments gets you involved in the Flickr community.

Want to add your own comment and join the discussion? Just scroll to the bottom of the comments list, as shown in Figure 4.9.

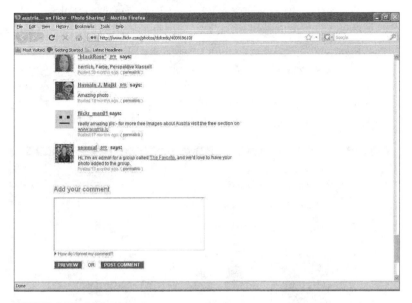

FIGURE 4.9 Adding a comment.

Enter your comment into the Add Your Comment box; click the Preview button to see a preview of your comment, or click the Post Comment button to post your comment directly.

Adding Contacts

We've mentioned a lot about contacts, friends, and family on Flickr. Now it's time to start putting that work.

So what's the difference between contacts, friends, and family? Here's your answer:

▶ **Contacts**: In general, contacts are people you want to keep up-to-date with. When a contact posts to his or her photostream, that post will also go (in thumbnail form) to your Contacts page

(click the Contacts link on any Flickr page to see the Contacts page) and your home page.

▶ **Friends**: Contacts you've marked as friends can also see the photos you've marked accessible to friends.

▶ **Family**: Contacts you've marked as family can also see the photos you've marked accessible to family.

Suppose, for example, that you're looking at someone's photostream, such as the one in Figure 4.10, and want to add that person as a contact.

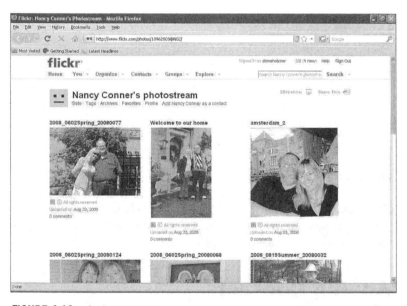

FIGURE 4.10 A photostream.

It's easy: Just click the Add *xxxxxxxxx* as a Contact link in the person's photostream or profile, where *xxxxxxxxx* is the person's name. When you click that link, a dialog box appears, as shown in Figure 4.11.

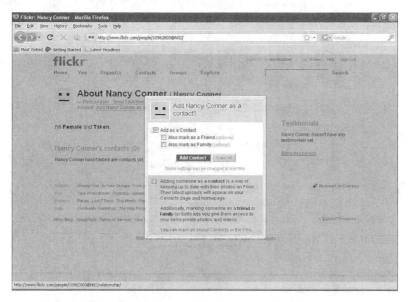

FIGURE 4.11 Adding someone as a contact.

This is the dialog box you use to add someone as a contact, as a friend, or as a family member (or all). The three check boxes in the dialog box let you specify what level you're adding the new contact as:

▶ Add as a Contact

▶ Also Mark as a Friend (optional)

▶ Also Mark as Family (optional)

After you've specified your selection, click the Add Contact button.

The person is added as one of your contacts. You'll be able to see that person's recent activity in Flickr on the Contacts page. (To see the Contacts page, click the Contacts link visible on every Flickr page.) The Contacts page appears in Figure 4.12, and you can see the new contact's recent uploads.

FIGURE 4.12 The Contacts page.

Note that the person you made a contact will get an email. Here's what that email will look like:

> *xxxxxxxxx,*
>
> You are steveholzner's newest contact! If you don't know steveholzner, steveholzner is probably a fan of your photostream or wants a bookmark so they can find you again. There is no obligation for you to reciprocate, unless you want to. :)
>
> If not, you might like to have a look at his profile:
>
> http://www.flickr.com/people/40034084@N07/
>
> You can see all of his contacts here:
>
> http://www.flickr.com/people/40034084@N07/contacts/
>
> And photostream here:
>
> http://www.flickr.com/photos/40034084@N07/

If you'd like to make them a contact too, click on this
link:

http://www.flickr.com/people/40034084@N07/relationship/
Congratulations—you've just added a new contact.

Finding Friends

Now that you've seen how to add people as contacts, how about finding
your pals on Flickr? Or if they're not already on Flickr, how about invit-
ing them to join?

You can do both—and we'll take a look at both topics, finding friends and
inviting friends, next.

Searching for Friends

To search for friends you want to add as contacts, go to your home page and
click the Find Your Friends on Flickr link that you can see in Figure 4.13.

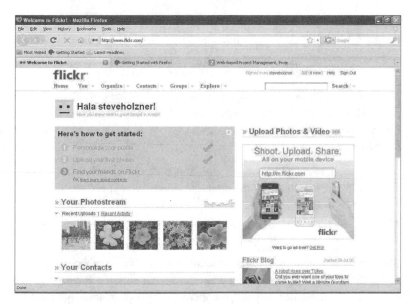

FIGURE 4.13 The home page.

Clicking the Find Your Friends on Flickr link opens the page shown in Figure 4.14.

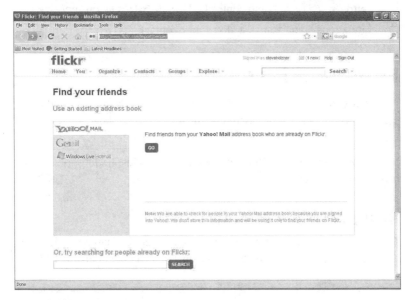

FIGURE 4.14 The Find Your Friends page.

You can also reach this page at www.flickr.com/import/people/.

There are actually two ways to search for friends, as you can see on the page in Figure 4.14. The first way is to search your email address book for friends who are already on Flickr. The second way is to search Flickr for the names of your friends.

If you have an email address book with Yahoo!, Gmail, or Hotmail, you can have Flickr search for all the email addresses in your address book to see if any of those people have Flickr accounts. Just select the email address book type on the left on the Find Friends page, click the Go button, and follow the directions.

If you want to search for friends by name, enter his name in the search box at the bottom of the page and click the Search button. Clicking the buddy icon of those people you find opens their photostream, which lets

you determine whether you've found the right person—and add them as a contact if so.

FIGURE 4.15 Search results.

On the other hand, not all your friends are going to have Flickr accounts. How about inviting your off-Flickr friends to join Flickr?

Inviting Friends

How do you invite people not on Flickr to join so you can see your friends and family photos)? You can use the handy Flickr Invite Friends form.

Just follow these steps:

1. Navigate to your home page at Flickr.com and sign in if you're not already signed in.

2. Click the Contacts link to open the Contacts page.

3. Click the Invite link to open the Invite page, as shown in Figure 4.16.

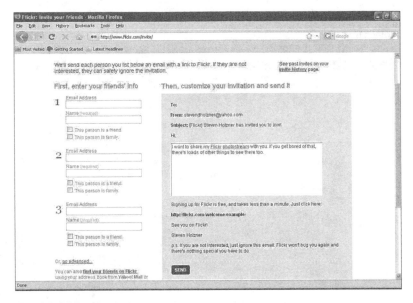

FIGURE 4.16 The Invite page.

4. Fill in this information for each friend you want to invite:

 ▶ Email Address

 ▶ Name (required)

 ▶ This Person Is a Friend (check box)

 ▶ This Person Is Family (check box)

5. Customize the email sent to each friend by customizing each of these fields:

 ▶ From: *stevendholzner@yahoo.com*

 ▶ Subject: [Flickr] *Steven Holzner has invited you to join!*

 ▶ Body:

 Hi,

 I want to share my Flickr photostream with you. If you get bored of that, there are loads of other things to see there too.

Signing up for Flickr is free, and takes less than a minute. Just click here:

http://flickr.com/welcome/example/

See you on Flickr!

Steven Holzner

p.s. If you are not interested, just ignore this email. Flickr won't bug you again and there's nothing special you have to do.

6. Click the Send button.

> TIP
>
> You can see a history of your invitations—which ones were accepted or rejected—at www.flickr.com/invite_history.gne/.

Managing Your Contacts

When you've got a number of contacts, it pays to be able to manage them. You might want to see all your contacts in list form (for example, showing their most recent activity).

In addition, you might want to change whether any of your contacts are specified as friends or family.

You can do these things and manage your contacts with the Contact List page. Just follow these steps:

1. Navigate to your home page at Flickr.com and sign in if you're not already signed in.

2. Click the Contacts link to open the Contacts page.

3. Click the Contact List link to open that page, as shown in Figure 4.17.

FIGURE 4.17 The Contact List page.

Want to change a contact's friend or family status?

Just click the Friend & Family (Edit) link to open the page you see shown in Figure 4.18.

You can make the changes you want to the contact's name and click the OK button to save the contact's new status.

> TIP
>
> How do you remove a contact? You can't do that from the Contact List page. Instead, you can go to someone's profile page, click the link that is similar to "*Edward* Is a Contact. Change?" On the next page, you can delete that person as a contact.

While we're on the Contact List page, click the Around You link in the Activity section at the bottom of the page to open the page shown in Figure 4.19.

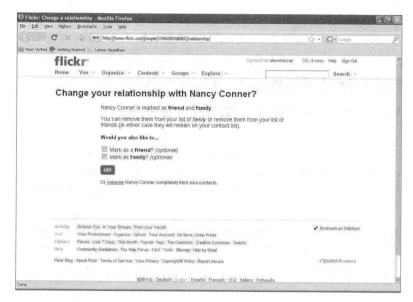

FIGURE 4.18 Editing a contact.

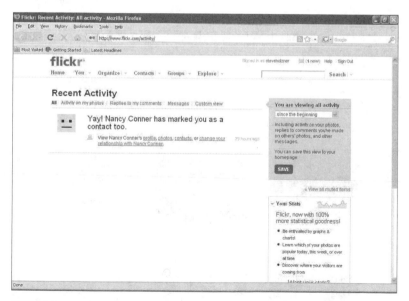

FIGURE 4.19 The activity around you.

This page lists the recent activities that concern your account. (If you're familiar with Facebook, this is Flickr's analog to the Facebook minifeed.)

Making Photos Viewable to Friends and Family

You already know you can set the privacy of your photos when you upload them. Now that you're adding friends and family to your contacts list, you might want to edit the privacy settings of your photos after they've been uploaded—no use letting Aunt Jane see that slightly ridiculous Christmas party picture.

You can edit the privacy settings of any photo in your photostream—and you can set who can comment and add tags, too. Just follow these steps:

1. Navigate to your home page at Flickr.com and sign in if you're not already signed in.

2. Click the Your Photostream link to open your photostream, as shown in Figure 4.20.

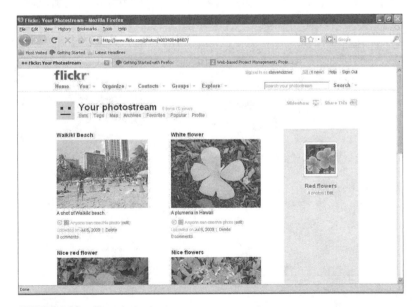

FIGURE 4.20 The photostream.

3. Find the photo whose privacy setting you want to change and click its Edit link (which looks something like Anyone Can See This Photo [Edit]).

4. Customize the privacy setting of the photo with the radio buttons and check boxes:

▶**Who Can See This Photo?**

Only You (Private)

▶ Your Friends

▶ Your Family

Anyone (Public)

▶**Who Can Comment?**

Only You

Your Friends and/or Family

Your Contacts

Any Flickr User (Recommended)

▶**Who Can Add Notes & Tags?**

Only You

Your Friends and/or Family

Your Contacts (Recommended)

Any Flickr User

5. When you're done, click the Save button.

Inviting People with a Guest Pass

Not everyone you invite to join Flickr to see your photos will want to actually join Flickr. Is there a way to let your invitees see the photos marked for friends and/or family anyway?

Yes, there is: You can give them a Flickr *guest pass*. You can issue a guest pass for any set that has some or all of its photos marked nonpublic. (Non-Flickr members can always see public photos.)

Suppose, for instance, that you have a set with some private photos and want to issue a guest pass to someone so he can see the set without being a member of Flickr. Here's how it works:

1. Navigate to your home page at Flickr.com and sign in if you're not already signed in.

2. Click the Your Photostream link to open your photostream.

3. Click the set with the private photos, opening that set.

4. Click the Share This link at the upper right, opening the dialog box shown in Figure 4.21.

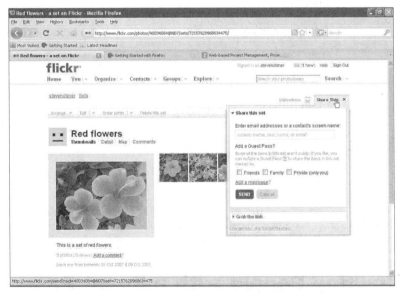

FIGURE 4.21 Sharing a set with a guest pass.

5. Enter the email address or screen name of the person you want to send the guest pass to.

6. Select the level of the guest pass:

> ► Friends

> ► Family

> ► Private (only you)

7. Add an optional message.

8. Click the Send button.

These directions send an email with an automatic guest pass to anyone.

You can also get a link to your set (and make sure the link has a guest pass built in). Just click the Grab link, click the check boxes to make the guest pass (Friends, Family, or Private), and copy the link, which you can then send to people yourself.

TIP

Want to see the history of the guest passes you've created? Take a look at www.flickr.com/invite/history/guests/.

Blocking People

You can also block people from having anything to do with you on Flickr. When you block people, they:

► Can't comment on your photos.

► Are removed as your contact, and you are removed as theirs.

► Can't add your photos as favorites.

► Can't add notes or tags to your photos.

► Can't send you FlickrMail (the mail system between Flickr members, discussed in Lesson 8, "Favorites, FlickrMail, and Printing").

You can block a person by going to their profile page (go to their photostream and click the Profile link) and clicking the Block This Person? link. That's all it takes.

Note that people you block are not notified that you've blocked them.

> TIP
>
> To see the people you've blocked, click the Your Block List link at the bottom of your Contact List.

Summary

This lesson started our discussion about sharing photos on Flickr. You learned how to look at other people's public photos. You also saw how to search for friends and make people into contacts, including friends and family. You learned how to share photos, even with non-Flickr members, using a guest pass. Finally, you saw how to block people from any interaction with you on Flickr.

Sharing Photos: Groups

One of the most social aspects of Flickr is *groups*, those collections of members that gather around a common interest and share photos.

There are thousands of Flickr groups, and you can easily search for the groups you might want to join.

You can also create your own groups—you don't need a Pro account or anything special to do so. You'll see how to create your own groups in this lesson, too.

Let's start digging into groups now.

Welcome to Groups

Flickr groups let Flickr members come together around some common interest and share photos (and video) as well as interact with a discussion board.

There are three types of groups on Flickr:

▶ Public

▶ Public, Invitation Only

▶ Private

You can search for any public group, but can only join the public groups—unless you have an invitation to a public (invitation only) group. Private groups are not searchable, and you need an invitation to join.

Why join a group? You can often view photos in a group—called the *photo pool* of the group—without being a member. But membership has its privileges. For example, you can only post photos to the group pool if you're a member.

We'll start by taking a look at how to find groups you might be interested in on Flickr.

Finding a Group

Let's say you have a special interest in a particular topic and want to track down photos in that topic—perhaps even discuss that topic with other people. You can do so in Flickr with groups.

For example, suppose you've just returned from your vacation to Hawaii and want to see if there are any groups on Hawaii. How can you do that?

You can start on your Flick home page at Flickr.com. After you've logged in (not necessary if Flickr has already logged you in), you'll see a link under the Flickr name that says Groups. Click it to open your Groups page, as shown in Figure 5.1.

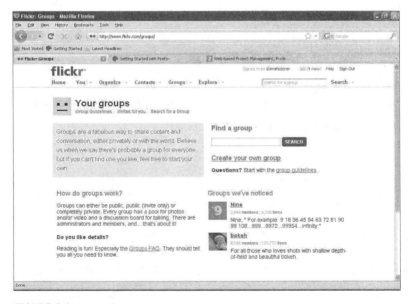

FIGURE 5.1 Your Groups page.

Note the sections in this page. There's a general welcome message, and underneath that, a link to the (short) Group FAQ.

On the right, you can see a search box that lets you search through the existing groups. Underneath that is a link to creating your own group.

At the bottom on the right is a small section, Groups We've Noticed, that the Flickr staff puts up to publicize groups it has noticed and wants to bring to people's attention. Each group has a group photo, some information about the number of people in the group and the number of items in the group pool, and a text description of the group. To see the group's page, click the group photo.

Let's search for groups having to do with Hawaii. Enter the term **Hawaii** into the search box and click the Search button. Doing so brings up the page shown in Figure 5.2.

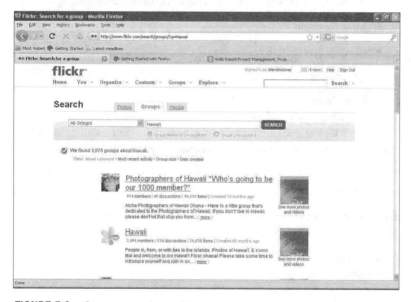

FIGURE 5.2 Groups search results.

Did we find any groups having to do with Hawaii? Well, yes—as you can see in Figure 5.2, Flickr says, "We found 3,875 groups about Hawaii." Not a bad haul.

Note that the search box has sprouted new options here. Using the dropdown list next to the search box, you can now search among

- ▶ All Groups

- ▶ Choose from Your Groups

So now you have the option of searching among the groups you're a member of as well as searching all groups.

You can also specify where to search for search terms using the radio buttons under the search box:

- ▶ Group Names & Descriptions

- ▶ Group Discussions

You can also select how to view the search results; for example, by

- ▶ Most Relevant

- ▶ Most Recent Activity

- ▶ Group Size

- ▶ Date Created

Let's take a look at one of the groups we've found—the Hawaii group. (The name seems promising when you're looking for groups about Hawaii.)

Clicking the Hawaii group in the search results opens that group's page, as shown in Figure 5.3.

Each Flickr group is "based" on its group page, such as the Hawaii group's page in Figure 5.3.

Note the links under the group name, giving you access to the most common features of the group:

- ▶ Group Pool

- ▶ Discussion

- ▶ 2,801 Members

- ▶ Map

- ▶ Join This Group

FIGURE 5.3 A Flickr group.

You can see an abbreviated version of the group pool on the group page, as shown in Figure 5.3. To see more thumbnails from the group pool, click the Group Pool link. To see the full photo, click the photo's thumbnail.

To see the current discussions on the discussion board, click the Discussion link, opening the page you see in Figure 5.4.

You can see the various discussion threads in Figure 5.4. To read a thread, click it, opening the thread's page, as shown in Figure 5.5.

Want to post to the discussion? Only members can post—and we'll join in a couple of pages.

You might also take a look at the map, by clicking the Map link, which brings up the page you see in Figure 5.6.

FIGURE 5.4 A Flickr group's discussion group.

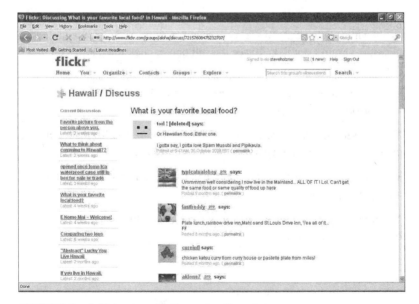

FIGURE 5.5 A Flickr group's discussion thread.

FIGURE 5.6 A Flickr group's map.

Flickr takes a random sample of the geotagged photos in the group and displays their location on a map (see Figure 5.6). As you can see, all the photos come from Hawaii—no surprise there.

Want to join this group, which will let you submit photos to the pool and join in the discussions? That's coming up next.

Joining a Group

To join a group, go to the group's page and click the Join This Group link, opening a page like the one you see in Figure 5.7.

To join, click the Join This Group button. That's all it takes to join a group that's public and doesn't need an invitation.

How do you know you've actually joined? Go to your Groups page (that is, go to your Flickr home page and click the Groups link) to see the new group listed there, as you see in Figure 5.8.

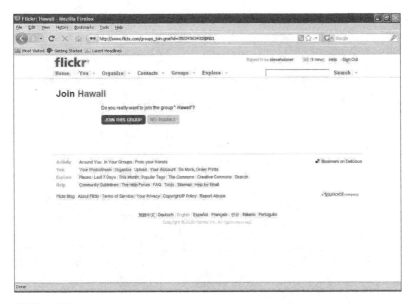

FIGURE 5.7 Joining a group.

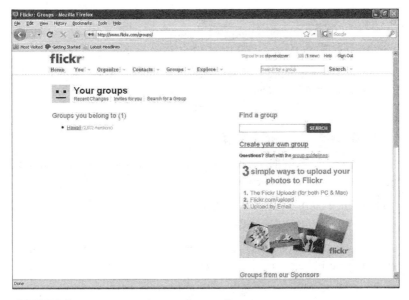

FIGURE 5.8 A new group in your Groups list.

In addition, on the group's page, you'll find the Join This Group link has become an Invite Friends link.

Okay, now that you've joined a group, how about posting some photos to the group?

Sharing Photos

Want to share a photo in a group's pool? Follow these steps:

1. Navigate to your home page at Flickr.com and sign in if you're not already signed in.

2. Click the Your Photostream link to open your photostream.

3. Click the photo you want to share to open the photo's page, as shown in Figure 5.9.

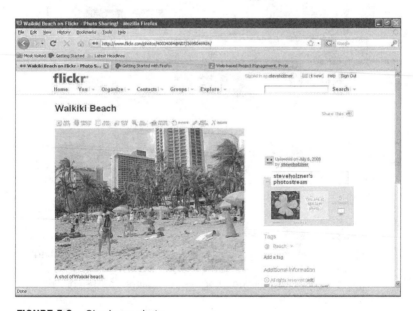

FIGURE 5.9 Sharing a photo.

4. Click the Send to Group button that appears between the photo and the photo title, which opens a drop-down menu.

5. Select the name of the group you want to send the photo to from the drop-down menu.

6. Flickr displays a dialog box telling you that the photo has been added to the group. Click OK.

The photo now appears in the group's photo pool, as you see in Figure 5.10. (You can see the thumbnail at the upper left in the group pool.)

FIGURE 5.10 A photo shared with a group.

TIP

It's important that you realize if you share a photo that you marked private with a group, the other group members have full access to that photo. Note also that the photo isn't displayed for people who aren't members of the group.

Want to remove a photo from a group? After you've added a photo to a group, the name of that group will appear at the right on the photo's page—along with an X after the group name. To remove the photo from the group, just click the X.

You might also be interested to know there's a limit to the number of groups you can add a particular photo to. If you have a free account, you can add a photo to up to 10 groups. If you have a Pro account, you can add a photo to up to 60 groups.

What if you've posted the photo to the limit of groups you're allowed? There's no way around it but to remove the photo from one of the groups you've already posted it to.

> TIP
>
> If your photo doesn't show up in a group pool, it might be because of some new abilities Flickr has given to group administrators. Now group administrators can automatically screen out photos that are not marked safe, not geotagged, not a photo, or not a video.

Joining the Discussion

Now that you've become a member of a group, you can participate in the group's discussions.

To add a comment to a thread, follow these steps:

1. Navigate to your home page at Flickr.com and sign in if you're not already signed in.

2. Click the Groups link.

3. Click the group in which you want to add to the discussion, opening the group's page.

4. Click the Discussion link in the group's page, opening the discussion's page.

5. Click the thread you want to add a comment to, opening that thread's page.

6. Scroll down to the bottom of the list of replies.

7. Enter your reply in the Reply to This Topic box.

8. Enter your reply; click the Preview button to see what your reply will look like, or the Post Now button to post your reply to the discussion.

If everything worked as it should, your reply will appear at the bottom of the list of replies (see Figure 5.11).

FIGURE 5.11 A reply to a thread in a discussion.

> **TIP**
>
> Can you paste photos into discussion posts? Yes, you can. There's no built-in way on Flickr to do this, though; you rely on your browser to do this. Go to the photo's page that you want to insert and click the All Sizes link, and then select the image you want to insert into the discussion. (Most people choose small.) Then right-click the photo and copy it using your browser's shortcut menu. (Most often, this menu item says Copy or Copy Picture.) Then, when you're writing your post, right-click the page and select Paste to paste the photo into the text you are typing.

Creating a Group

Sometimes nothing but creating your own group will do. You might find to your surprise that there's no group focused on ostrich beaks or stingray tails and decide that it's time to create one.

Creating a group isn't hard, although you should take the responsibilities of group administration seriously. There are thousands of Flickr groups, and because the administrators lost interest, many are more or less dead. As your new groups' creator, you're its first administrator.

In this example, we'll create a public group for vacation photos, named Wish You Were Here - Vacation Photos.

To create a new Flickr group, follow these steps:

1. Navigate to your home page at Flickr.com and sign in if you're not already signed in.

2. Click the Groups link.

3. Click the Create Your Own Group link to open the page shown in Figure 5.12.

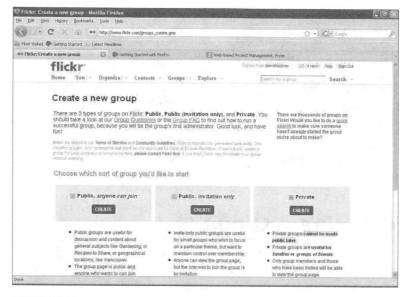

FIGURE 5.12 The group-creation page.

There are three types of groups you can create:

▶ Public

▶ Public, Invitation Only

▶ Private

Here's how Flickr describes public groups:

▶ Public groups are useful for discussion and content about general subjects like Gardening, Recipes to Share, or geographical locations, like Vancouver.

▶ The group page is public and anyone who wants to can join instantly.

▶ Admins can choose to show or hide discussions and/or group pools from nonmembers.

Here's how Flickr describes public invitation-only groups:

▶ Invite-only public groups are useful for small groups who want to focus on a particular theme, but want to maintain control over membership.

▶ Anyone can view the group page, but the only way to join the group is by invitation.

▶ Admins can choose to show or hide discussions and/or group pools from nonmembers.

And here's how Flickr describes private groups:

▶ Private groups cannot be made public later.

▶ Private groups are useful for families or groups of friends.

▶ Only group members and those who have been invited will be able to view the group page.

▶ Private groups are completely hidden from group searches and don't display on people's profiles amongst groups they belong to.

4. Click the Create button for the type of group you want to create—Public, Public (Invitation Only), or Private.

This example will create a public group.

Clicking the Create button opens the new page you see in Figure 5.13, which asks questions about your new group.

5. Enter the name of your new group.

6. Enter a description for your group.

TIP

People will find your group by searching the title and description, so make sure you include plenty of keywords.

7. Select the radio button that indicates whether your group is intended for 18+ or not.

8. Click the Next button to bring up the page you see in Figure 5.14.

This page lets you design your group's page.

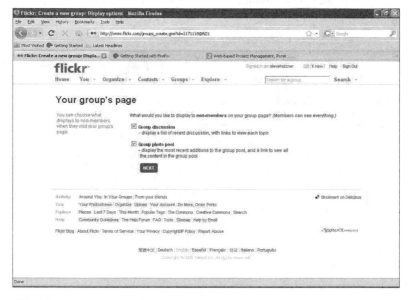

FIGURE 5.13 Creating a new group.

FIGURE 5.14 Designing your group's page.

9. Select the radio buttons corresponding to the items you want on your group's page: Group Discussion and Group Photo Pool.

10. Click Next, opening the page shown in Figure 5.15.

FIGURE 5.15 Selecting names for people in your group.

This page lets you select the names by which the people in your group will be known:

- ▶ Administrators
- ▶ Moderators Of
- ▶ Members

11. Enter the names for the three levels of people in your group or accept the default names Flickr offers (shown in Figure 5.15); click the All Done button, opening the page you see in Figure 5.16.

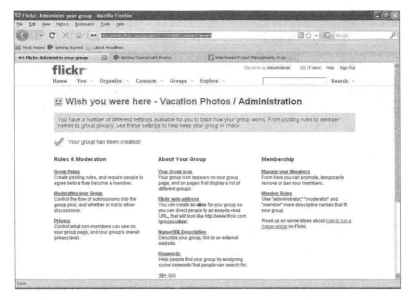

FIGURE 5.16 The All Done page.

Your new group has been created. Congratulations!

Customizing Your Group Icon

The page you see in Figure 5.16 lets you continue the set up of your group, and it lets you administer your group. (You can always reach the group's administration page by opening the group page and clicking the Administration link, which will be visible because you're an administrator.)

Note in particular the middle column in Figure 5.16, which lets you customize the following:

- ▶ Group Icon
- ▶ Flickr Web Address
- ▶ Name/URL/Description
- ▶ Keywords
- ▶ 18+ Info

Let's customize a few aspects of our group now, starting with the group icon. To set the group's icon, follow these steps:

1. Click the Your Group Icon link in your group's administration page.

2. In the page that opens, click the link that describes where your group's icon will come from:

- ▶ In Your Photostream

- ▶ On Your Computer

- ▶ On the Web

In this example, we'll fetch an icon from our photostream, so click that link.

3. The next page displays your photostream. Click the photo you want to make into the group icon.

4. In the next page, click the Make the Icon button.

Now when you open your group's page (go to your Flickr home page, click Groups, and click the group name you want to open), you'll see the group's icon, as shown in Figure 5.17.

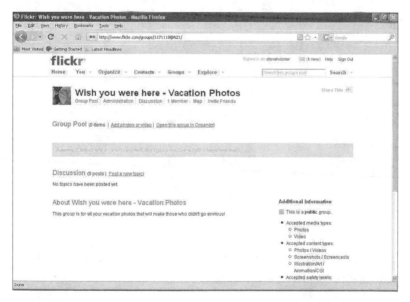

FIGURE 5.17 The new group's page.

Okay, let's see about customizing the group's keywords.

Customizing Your Group's Keywords

How about adding some keywords to your group to make it even easier for people to find your group?

To add keywords, follow these steps:

1. Go to your Flickr home page (at Flickr.com) and log in if you're not already logged in.

2. Click the Groups link.

3. Click the name of the group you want to add keywords to.

4. In the group's page, click the Administration link.

5. Click the Keywords link, opening the page you can see in Figure 5.18.

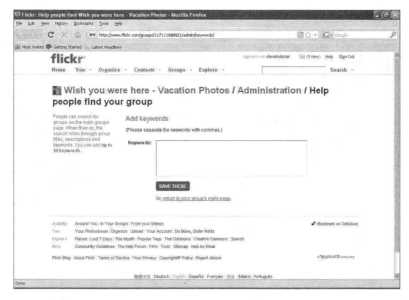

FIGURE 5.18 Adding new keywords to a group.

6. Enter the keywords you want to give to the group in the text box.

7. Click the Save These button.

That's it. You've now added new keywords to your group, letting people search for your group via its name, description, and keywords.

Okay, you've set up your new group. Now how about taking a look at how to administer the members?

Administering Your Group

When you create a group, you're the group's first administrator. Admins have just about unlimited power in a group. According to Flickr, admins can

- ▶ Modify information about the group
- ▶ Create or change the group name
- ▶ Create or change the group description
- ▶ Associate the group with an external URL
- ▶ Create a personalized URL for the group (like your photostream, this URL can only be set once so choose wisely)
- ▶ Determine whether your group topics or pool can be viewed by nonmembers
- ▶ Create a group icon
- ▶ Determine group moderation rules:

 What kind of content can be added to the group pool (photos, video, or both)

 Set frequency of group pool submissions

 Determine what safety level of content is appropriate for the group (safe, moderate, or restricted)

 Create group participation rules

You can administer the content of your group by deleting photos or discussion items. Just click the Delete link you'll see (as an admin or a moderator) next to those items.

As the group's admin, you can also make others into admins or moderators. We'll take a look at that now.

Creating Moderators and Admins

You can make as many group members into admins as you like. If you don't want to give people all the power of admins (such as changing the name of the group), you can make them moderators.

A moderator can remove inappropriate submissions and discussion posts and remove people from membership if they violate the rules.

How do you make someone an admin or a moderator?

Just follow these steps:

1. Go to your Flickr home page (at Flickr.com) and log in if you're not already logged in.

2. Click the Groups link.

3. Click the name of the group you want to add keywords to.

4. In the group's page, click the Administration link.

5. Click the Manage your Members link, opening the page you see in Figure 5.19.

6. Click the Members link to display your group's members, as shown in Figure 5.19.

7. Click the Promote link for the member you want to promote to admin or moderator, making a drop-down list appear.

8. Select Moderator or Admin in the drop-down list and click the OK button that appears under the list box.

That's all it takes.

What if you have to remove someone from your group?

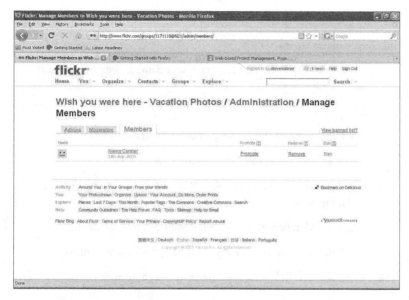

FIGURE 5.19 Managing your group's members.

Banning and Removing

You can remove or ban people from your group. If you remove someone, that person can come back to your group. If you ban someone, however, no comeback is possible. Here's what Flickr has to say on the issue:

- ▶ If a troll types or posts something offensive, they should be warned.

- ▶ If they continue their behavior, they should be removed. You can do this from the Admin view of the members list.

- ▶ If they come back and continue their behavior, they should be banned. You can do this from the Admin view of the members list.

How do you remove or ban someone?

Just follow these steps:

1. Go to your Flickr home page (at Flickr.com) and log in if you're not already logged in.

2. Click the Groups link.

3. Click the name of the group you want to add keywords to.

4. In the group's page, click the Administration link.

5. Click the Manage your Members link, opening the page you see in Figure 5.19.

6. Click the Members link to display your group's members.

7. Click the Remove link for the member you want to remove.

8. Click the Ban link for the member you want to ban.

Summary

This lesson covered Flickr groups. You saw how to search for groups and how to join them. You learned how to submit photos to the group pool and engage in discussions. In the second half of this lesson, you saw how to create your own group and how to customize it. You also learned how to administer your new group.

LESSON 6

Editing Your Photos

Flickr is more than just a pretty face—it also offers some real functionality when it comes to editing your photos.

Actually, this part of Flickr isn't really Flickr at all; it's a program called Picnik, which Flickr users can use for free, thanks to the Picnik people. You can also upgrade to Picnik Premium, which offers you a lot more power.

This lesson takes a look at what's available to Flickr users when it comes to editing your photos.

Welcome to Picnik

You can perform all kinds of operations and fixes on your photos using Picnik, such as the following:

- ▶ Auto-fix (performs some fixes that improve photo quality)
- ▶ Rotate photos
- ▶ Crop photos
- ▶ Resize photos
- ▶ Fix exposure
- ▶ Edit colors
- ▶ Sharpen photos
- ▶ Fix red-eye

And that doesn't even count the special effects and text capabilities of Picnik that we're going to see in this lesson.

How do you start Picnik from Flickr?

It's easy. Just follow these steps:

1. Navigate to your home page at Flickr.com and sign in if you're not already signed in.

2. Click the Your Photostream link to open your photostream.

3. Click the photo you want to share to open the photo's page, as shown in Figure 6.1.

FIGURE 6.1 A photo to edit.

4. Click the Edit Photo link above the photo, opening Picnik as shown in Figure 6.2.

There are a few things to notice about the Picnik page. Your photo is opened in the Edit tab, so bear that in mind. There's also the Create tab for special effects.

FIGURE 6.2 A photo in Picnik.

The various tools available, such as Auto-Fix and Red-Eye correction, appear as buttons on the page, as you can see above the photo.

The photo has been sized to fit the Picnik workspace, as you can see with the zoom bar at lower right, which indicates the image is appearing at 88% its normal size. You can use the zoom box to zoom the photo to whatever size you want.

> **TIP**
>
> Got a mouse wheel on your mouse? Roll the wheel and Picnik will zoom or shrink the photo accordingly.

Note, finally, the Save button at the upper right. Clicking that will save your work in Flickr. And notice the Undo button, which is great because you can undo the preceding operation.

Let's start taking a look at the tools that Picnik has to offer you in the Edit tab.

Auto-Fix Your Photos

The first button in the toolbar on the left is Auto-Fix.

The Auto-Fix button makes some changes to your photo that Picnik considers common fixes, such as enhancing colors and adjusting the contrast.

For example, if you click the Auto-Fix button on the white flower shown in Figure 6.2, Picnik adjusts the contrast and shows a new, brighter flower, as shown in Figure 6.3.

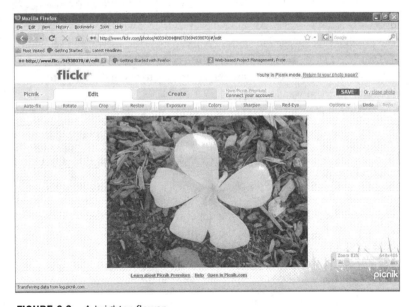

FIGURE 6.3 A brighter flower.

Give auto-fix a try. It usually improves photos dramatically, and it's a quick way to edit photos, one after the other. If you want to polish your photos on Flickr, just edit them and click Auto-Fix, then click the Save button.

When you click the Save button, you'll see a dialog box like the one shown in Figure 6.4.

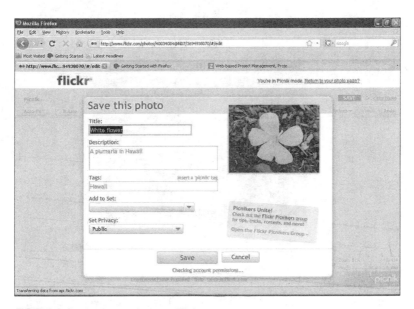

FIGURE 6.4 Saving a photo to Flickr.

Note that what's really happening when you save a photo in Picnik is that it's uploading your photo to Flickr, much as if you were using Uploadr.

You can set the title and description of the photo, just as you can with Uploadr, as well as the tags, the privacy level, and even add your photo to a set.

The original information that came with the photo—tags, title, description, and so on—will appear in the Save box. So if you don't want to make any changes to the photo's information, click the Save button to save the photo to Flickr.

Rotate Your Photos

Would your photo look better lying on its side? The Rotate tool is for you.
When you click it, Picnik changes to display the buttons shown in Figure 6.5.

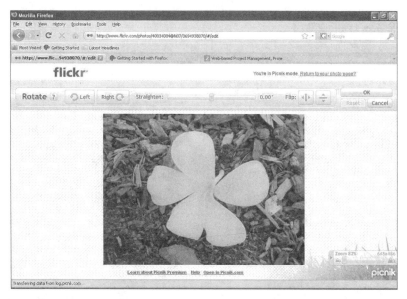

FIGURE 6.5 Rotate your photos.

The Left button rotates the photo 90° to the left (counterclockwise) each
time you click it.

The Right button rotates the photo 90° to the right (clockwise) each time
you click it.

You can use the Straighten bar to indicate to correct photos that were
taken at an angle. Move the slider bar to the left or right to tile the photo
in degrees. That's a great way to fix photos taken with a tilted camera.

The two flip buttons let you flip the photo horizontally or vertically.

When you're done, click the OK button to return to Picnik.

Crop Your Photos

This is a big one. Cropping (that is, trimming) photos accounts for much of the photo editing that goes on with Flickr users' use of Picnik.

How many times have you looked at a photo and noticed that what you really want to present is actually in a small space of the entire photo? A face or a house, for example—not the whole landscape.

The Crop tool lets you crop your photos, retaining just the part you want. When you click the Crop tool, Picnik changes to what you see shown in Figure 6.6.

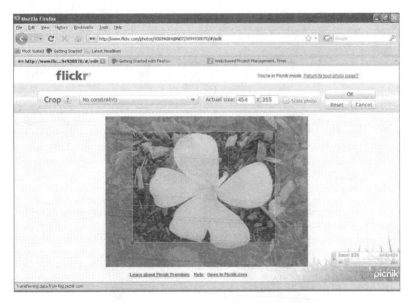

FIGURE 6.6 Cropping a photo.

A draggable box appears in your photo, and you can use the mouse to drag the corners of the box to crop just the part of the image you want. Then click OK to make Picnik make the change to the photo.

This is one of Picnik's most useful tools for the Flickr user, letting you crop just the parts of an image you want to present. Very nice.

> **TIP**
>
> One of the features of the Crop tools is the constraints drop-down list, which you can see in Figure 6.6. With this drop-down list, you can constrain the cropping area to have the original proportions of the photo, to be square, the golden ratio, or several other ratios, each of which is hard to set exactly when you're just dragging the box with the mouse.

Resize Your Photos

Flickr is pretty rigid when it comes to photo sizes, storing images in the sizes it selects (except for Pro users, who can also store images in their original sizes).

With Picnik, you can set the size of a photo yourself. Just click the Resize button to change the Picnik display to that shown in Figure 6.7.

FIGURE 6.7 Resizing a photo.

As you can see in Figure 6.7, you can set the new dimensions of the photo using pixel measurements. Just enter the new size and click OK.

You can also specify percentages for the horizontal and vertical dimensions, not pixel measurements. That's great if, say, you want to stretch a photo by two times in both dimensions. To use percentages rather than pixel measurements, just check the Use Percentages check box.

You can also specify that Picnik retain the current proportions of your photo by checking the Keep Proportions check box. (It's checked by default.)

Fixing Your Photos' Exposure

Got any photos that came out overexposed? Or underexposed? That's a matter of contrast, and you can fix that with the Exposure tool in Picnik, which makes Picnik display the controls you see in Figure 6.8.

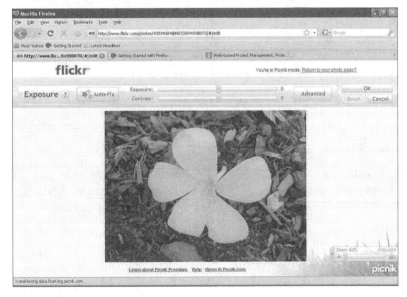

FIGURE 6.8 Fixing a photo's exposure.

A quick way of fixing the contract and exposure of a photo is to click the Auto-Fix button. That button appears to do exactly the same as the Auto-Fix tool in the main Picnik page, but it's still a useful tool for fixing the contrast and exposure of a photo automatically.

You can also set the exposure or contrast of a photo manually, using the slider bars you see in Figure 6.8.

> **TIP**
>
> Want to fix the contrast in a photo part by part? Click the Advanced button to give you that ability—you can adjust the contrast in various parts of the photo differently.

Editing Colors

What's a photo editor without the capability to edit the colors in a photo? You can edit colors with the Flickr version of Picnik, but not in super-detail.

To see what's available, click the Colors tool in Picnik, which causes Picnik to display the page you see in Figure 6.9.

The first button, Auto Colors, lets Picnik select and enhance the colors in the photo. It's worth a try (click the Reset button to undo what this button does), but the results might surprise you. For example, it turned the white flower in Figure 6.9 blue.

The next button, Neutral Picker, lets you click a region of white or gray color in your photo, and Picnik will adjust the colors based on that. Click the Neutral Picker button, and then click a region in the photo itself.

You cannot adjust the red, green, and blue color levels directly, but you can adjust the saturation (that is, the intensity) of the colors and the temperature using the boxes you see in Figure 6.9. Getting used to these controls is best done through experimentation—increasing the temperature of your photo increases the red hues, for example—bearing in mind that the Reset button is there to undo any changes.

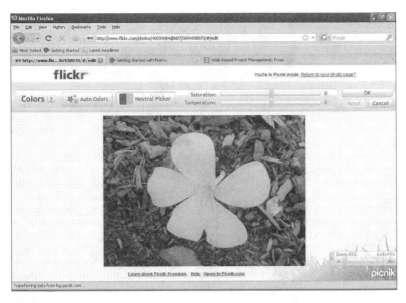

FIGURE 6.9 Editing colors.

Sharpening Your Images

Photo out of focus? Sharpen it!

The Sharpen tool in Picnik does exactly that and gives some surprisingly good results. You can see the Picnik Sharpen page in Figure 6.10.

To sharpen a photo, use the sharpen slider on this page, adjusting the sharpness as you like.

> TIP
>
> One type of photo that is practically essential to sharpen is a scan. If you've scanned an image, you'll be amazed at how improved it becomes when you sharpen it.

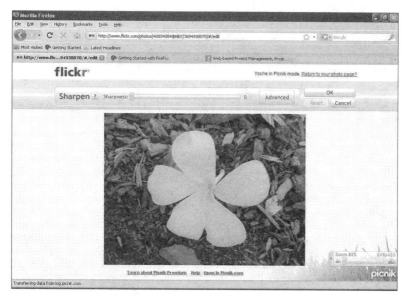

FIGURE 6.10 Sharpening an image.

Fixing Red-Eye

Flash cameras have a way of bringing out the worst of anyone's retina—that is, retinal reflections called red-eye.

You surely have seen flash photos where all the beaming faces have eyes as red as cherries. Well, Picnik is here to fix that for you.

Just click the Red-Eye tool to open the page you see in Figure 6.11.

You can fix red-eye by moving the mouse to the center of the eye and clicking. That's all it takes—Picnik will do the rest. The results can be somewhat spotty, but the red-eye in Figure 6.11 has been significantly reduced in the eye on the left (although that's hard to detect in a black-and-white figure).

Reducing red-eye like this is worth the price of admission to Picnik (especially because that's free for Flickr users). Many a good photo has been destroyed by red-eye, and this tool offers you the chance to fix that.

FIGURE 6.11 Fixing red-eye.

TIP

It's easier to use the Red-Eye tool if you magnify the photo you're working on. To do that, use the zoom bar at the lower right or rotate the mouse wheel a few times, and then apply the Red-Eye tool.

Using Effects

Now we'll turn to the effects available in Picnik. To access those effects, click the Create tab, opening the tab you see in Figure 6.12.

We'll cover the various effects and buttons in this tab now. Note that at the time of this writing, not all buttons are working; some features are in beta or unavailable.

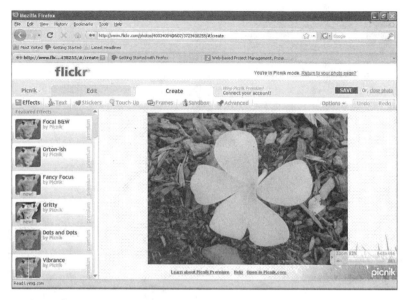

FIGURE 6.12 The Picnik effects.

Click the Effects button to see the actual Picnik effects, which are listed in the box on the left in Figure 6.12. There are plenty of effects available, and here they are. Note that some effects are available only to Picnik Premium members (although Picnik will often let you use them as long as it can put a logo on your photo that says "Premium feature"):

- Focal B&W (premium)
- Orton-ish (premium)
- Fancy Focus (premium)
- Gritty (premium)
- Dots and Dots (premium)
- Vibrance (premium)
- Panography-ish (premium)
- Black and White
- Sepia

- Boost
- Soften
- Vignette
- Matte
- Infrared Film (premium)
- Lomo-ish (premium)
- Holga-ish (premium)
- HDR-ish (premium)
- Night Vision (premium)

- ▶ Cinemascopr (premium)
- ▶ 1960's (premium)
- ▶ Tint (premium)
- ▶ Invert (premium)
- ▶ Duo-Tone (premium)
- ▶ Heat Map (premium)
- ▶ Cross Process
- ▶ Focal Soften (premium)
- ▶ Focal Pixelate (premium)
- ▶ Focal Zoom (premium)

- ▶ Pencil Sketch (premium)
- ▶ Neon (premium)
- ▶ Doodle
- ▶ Goofy (premium)
- ▶ Pixelate (premium)
- ▶ Puzzle (premium)
- ▶ Posterize (premium)
- ▶ Film Grain (premium)
- ▶ Snow

When you select one of these effects by clicking it, a number of controls appear, as shown in Figure 6.13 for the Doodle effect.

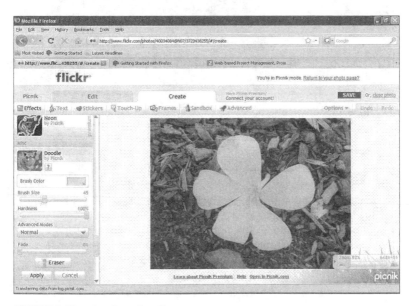

FIGURE 6.13 The Doodle effect.

Using the controls, you can customize the effect. When you click the
Apply button, the controls disappear, and the effect is applied. You can see
an example in Figure 6.14, where the Matte effect has been applied to our
flower photo. If you don't like what the new effect looks like, just click
the Undo button.

FIGURE 6.14 The Matte effect.

TIP

Beware the premium effects if you don't have Picnik Premium. When
you click one of the premium effects, that effect is applied immedi-
ately to your photo, and a banner "Premium Feature" is added to
your photo; the Undo button won't undo the change. (The Undo but-
ton is grayed out.) The only way to get rid of the change is to close
the photo in Picnik (click the Close Photo link) and reopen it from
Flickr again, which is pretty awkward.

Adding Text

Here's where you can add captions to your photos. You can add all kinds of explanatory text—how much that fish weighed, how high that high jump was, or add Happy Birthday greetings to Aunt Edna.

Adding text to photos is not for every photo, of course. But there's no denying that it can help in many cases. And you can add text to photos with the Picnik Text tool.

Just follow these directions:

1. Open the photo's page in Flickr.

2. Click the Edit Photo link to open the photo in Picnik.

3. Click the Create tab.

4. Click the Text button.

5. Enter text into the text box.

6. Click the Add button to add the text to the photo, as shown in Figure 6.15.

FIGURE 6.15 Applying text.

7. Move and size the text on your photo using the mouse.

8. Color the text and apply effects such as bold with the controls in the window on the right.

9. Click the Save button to save your changes back to Flickr.

Picnik foes a good job of selecting text colors based on your photo—for predominantly dark photos, for example, Picnik will draw white text.

Great! Now you know how to add text to photos!

Touching Up Photos

If you're a premium Picnik member, you can make use of the Touch-Up tool to touch up photos in detail, such as changing eye color, whitening teeth, removing skin blemishes, and more.

You access these tools by clicking the Touch-Up button in the Create tab of Picnik, which opens the page you see in Figure 6.16.

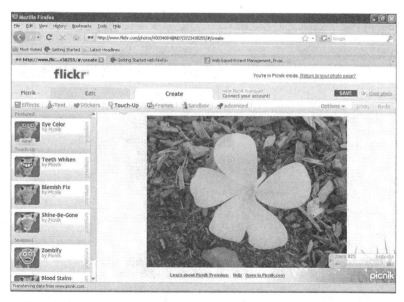

FIGURE 6.16 Touching up photos.

Here are the tools you can use to touch up photos—note that all these tools are for Picnik Premium users only:

- Eye Color (premium)
- Teeth Whiten (premium)
- Blemish Fix (premium)

- Shine-Be-Gone (premium)
- Zombify (premium)
- Blood Stains (premium)

Adding Frames

Frames look good on photos, and you can add a frame to your photos using Picnik.

Although there's a good selection of frames, unfortunately, only two are available to Flickr users without a Picnik Premium account: simple borders and rounded edges. You can see the Border frame in Figure 6.17.

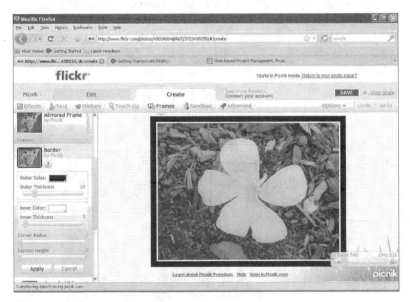

FIGURE 6.17　Adding a border.

Here are the frame types available:

- ▶ Before & After (premium)
- ▶ Reflection (premium)
- ▶ Postage Stamp (premium)
- ▶ Mirrored Frame (premium)
- ▶ Border

- ▶ Rounded Edges
- ▶ Drop Shadow (premium)
- ▶ Museum Matte (premium)
- ▶ Polaroid (premium)

Using Advanced Options

There are some advanced options as well for editing photos, such as drawing curves or cloning objects in your photos. Unfortunately, these options are only available to Picnik Premium users.

To access these options, click the Advanced button, opening the page shown in Figure 6.18.

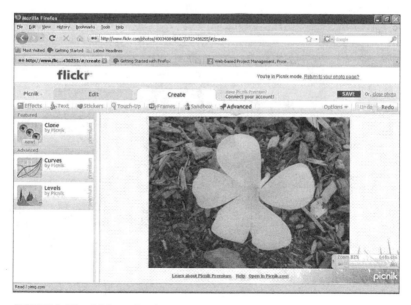

FIGURE 6.18 Adding a border.

Here are the advanced features available at this time:

- ▶ Clone (premium)

- ▶ Curves (premium)

- ▶ Levels (premium)

Summary

This lesson took a look at the editing capabilities given to Flickr users by Picnik. When you click the Edit Photo link on a photo's page, that photo is opened in Picnik. We took a look at the kind of editing operations you can undertake in Picnik, such as rotate, crop, resize, modify the contrast and colors, and so on. We also took a look at the effects offered by Picnik.

Working with Video

Flickr was founded when the Internet was still involved, in a visual sense, with pictures. Web pages were all about embedded photos and text. And Flickr was all about storing photos online.

You can imagine the Flickr staff's dismay as video, whose files are huge compared to photos, became popular on the Internet. To their credit, they now allow you to store video on Flickr.

Still, Flickr is no YouTube. If you've got a free account, you've limited as to what you can upload in a month. And as you're going to see, the videos you can upload on Flickr are more like clips than full video.

Still, Flickr has joined the video age, and with the advent of truly cheap video cameras (costing less than many digital cameras), uploading videos to Flickr is gaining steam. People upload video for the same reason they upload photos: to share them. Your aunt and uncle might want to see that holiday video you took at their house. Or you might want to brag about that time you finally got surfing right on your latest vacation. Or you might want to post baby videos rather than baby photos.

It's all possible on Flickr now.

Let's dig into this topic immediately.

Welcome to Video on Flickr

Flickr lets you store videos now, but there are limits on how much you can upload in a calendar month (that is, from midnight to midnight, Pacific time, from the first of the month to the end of the month).

If you have a free account, you can upload only two videos per month. Yep, that's it, so choose wisely. In addition, each video file must be smaller than 150MB. That's your limit.

Pro users, on the other hand, have it much easier. They can upload unlimited numbers of videos. Does that mean you can upload a DVD rip of your favorite *Star Trek* movie? No. For Pro users, video files are limited to 500MB in length.

What about HD video? High-definition video is becoming the new standard, and Flickr is taking notice. It allows you to upload HD video and display it, but only if you're a Pro user.

> TIP
>
> Actually, it turns out that you can upload HD videos, even if you're a free account user. But—and here's the mighty big catch—Flickr won't display it! So why are you allowed to upload HD video at all? Flickr says it allows free users to do that in hopes they'll switch to a Pro account.

Although there are many similarities with working with photos on Flickr, there are also many differences when it comes to working with videos. For example, you can't order a print of a video, and you can't rotate or edit a video.

Let's get started by seeing how to upload video now.

> TIP
>
> One thing to make sure of is that your video is ready for Flickr before you upload it—the upload limits are so strict you might not get another change this month (and note that you can't affect the size limits for videos by deleting photos either). Many popular video cameras that create AVI files in Windows aren't ready for Flickr, for example. They use a proprietary codex that the camera loaded onto your computer; without that codex, they won't play on other people's computers.
>
> A good test to make sure that your video is ready to be shared is to email a copy to someone else and see if it plays. (You don't have to do this for every video, of course, but you should make sure you don't need a proprietary codex for the videos your video camera creates). If the video won't play on someone else's computer, are you stuck? Not at all. You can get free software online to convert your video to another format. For example, if your camera produces proprietary AVI files, use converter software to convert your video to, say, WMV format instead (and test the results by emailing the converted video to a friend, too).

Uploading Video

There are as many ways to upload video as there are ways to upload photos on Flickr. When you upload video, you have all the standard options available to you with photos—you can set tags, privacy, descriptions, and so on.

We'll start with the standard uploading form.

Uploading with the Standard Form

You can upload videos with the standard upload form, just as you can with photos. Here's how:

1. Navigate to your home page at Flickr.com and sign in if you're not already signed in.

2. Click the Upload Photos & Video link to open the standard form shown in Figure 7.1.

FIGURE 7.1 Uploading a video with the standard form.

3. Click a Browse button and select the video you want to upload.

4. Click the Open button to make the video's path and name appear in the text box to the left of the Browse button.

5. Repeat steps 3 and 4 for a second video if you have another to upload, keeping in mind that if you have a free account you're limited to two video uploads a month.

6. In the Add Tags to the Whole Batch? box, add any tags you want to the videos.

7. In the Choose the Privacy Settings, select from the following settings:

 ▶ Private (Only You See Them)

 Visible to Friends

 Visible to Family

 ▶ Public (Anyone Can See Them)

8. Check the Show Advanced Settings check box to open the advanced settings.

9. In the Set Safety Level section, select from the follow three radio buttons:

 ▶ Safe (your default)

 ▶ Moderate

 ▶ Restricted

> **TIP**
>
> Restricted video isn't permitted on Flickr. Only safe or moderate videos can be uploaded and shared on Flickr. If you try to upload restricted video, Flickr will cancel your account.

9. In the Set Content Type section, make sure the first radio button is selected among these choices:

 ▶ Photos / Videos (your default)

 ▶ Screenshots

 ▶ Art, illustration, CGI, or Other Non-Photographic Images

10. In the Hide These Images from Public Searches? section, select the
Yes radio button if you want to hide your video from public searches.

11. Click the Upload button.

After the upload, you'll see the page in Figure 7.2, asking you to describe
this upload.

FIGURE 7.2 Completing an upload.

Follow these steps:

1. In the Add Tags section, add any tags you want to apply to the
whole upload (all videos).

2. If you want to add the uploaded videos to a set, select that set
from the Add to a Set section.

TIP

Note that you can create a new set by clicking the Create a New Set
link.

3. Add a title to each video in its Title box.

4. Add a description to each video in its Description box.

5. Add any individual tags to each video in its Tags box.

6. When you're done, click the Save button.

When you've saved the upload, the new videos appear in your photostream, as shown in Figure 7.3, where the uploaded video is the first item in the photostream. (The first frame of the video is displayed, which makes the video look like a photo—but note the small arrow button at lower left, indicating the item is actually a video, not just a photo.)

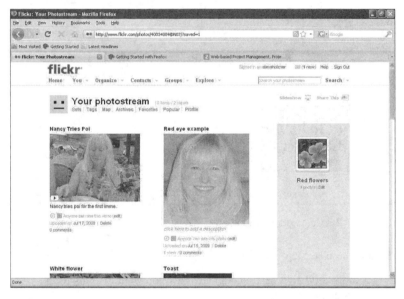

FIGURE 7.3　An uploaded video.

Want to see the video in action? Just click it to open the video's page, as shown in Figure 7.4.

FIGURE 7.4 A video's page.

Just click one of the two arrow buttons (one in the middle of the image) you see in the video to play the video.

Now you've uploaded video to Flickr. Not bad.

Note the buttons above the video offer a restricted set of options:

- ▶ Send to Group
- ▶ Add to Set
- ▶ Blog This
- ▶ Embed (get code to embed the video in other pages)
- ▶ Delete

This compares to photos, which have these buttons:

- ▶ Add Note
- ▶ Send to Group
- ▶ Add to Set
- ▶ Blog This
- ▶ All Sizes
- ▶ Order Prints
- ▶ Rotate
- ▶ Edit Photo
- ▶ Delete

Although the buttons are different, note that in many respects you can treat video like photos in Flickr. For example, you can add videos to a set, search for videos, and send videos to groups.

Uploading with the Flash Form

If your browser supports it, you can also upload videos using Flickr's Flash-based form. To do that, follow these steps:

1. Browse to your Flickr home page at Flickr.com and log in if Flickr doesn't automatically log you in.

2. Click the Upload Photos & Video link.

3. Click the Choose Photos and Videos link.

4. Navigate to the first video to upload in the dialog box that opens.

5. Select the video with the mouse and click Open, which will add the video to the upload list, as shown Figure 7.5.

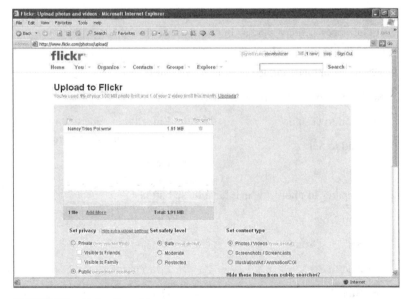

FIGURE 7.5 Uploading videos.

6. If you have more videos to upload, click the Add More link and repeat steps 4 and 5, adding the videos to the Upload list.

7. Click the Show More Upload Settings link.

8. Select the privacy options for the uploaded videos:

▶ Private (Only You See Them)

Visible to Friends

Visible to Family

▶ Public (Anyone Can See Them)

9. Set the safety level of the videos:

▶ Safe (your default)

▶ Moderate

▶ Restricted

10. Set the content type:

▶ Photos/Videos (your default)

▶ Screenshots/Screencasts

▶ Illustration/Art/Animation/CGI

11. Set whether you want to hide the videos from public searches.

12. Click the Upload Photos and Videos button.

13. Click the Add a Description Perhaps link, opening the Describe This Upload page.

14. If you're uploading more than one item and want to apply the same tags to all items, enter those tags in the Batch Operations/Add Tags text box.

15. If you want to add the upload to a set, select that set from the drop-down list box in the Add to a Set box.

16. Under each uploaded video, enter a title in the Title box.

17. Under each uploaded video, enter a description in the Description box.

18. Optionally, for each uploaded video, enter tags in the Tags box.

19. Click the Save button. Flickr will open your photostream or the set you added the videos to.

And there's still another way to upload video: You can use Uploadr, Flickr's dedicated upload tool.

Uploading with Uploadr

You can also upload videos with Uploadr, Flickr's dedicated upload tool.

If you don't have Uploadr installed, go to the Upload page (from your home page, click the Upload Photos & Video link). Then search for this text:

> We have desktop software available for Windows & Mac to help you get your photos and videos on to Flickr quickly and efficiently. Check out the Flickr Tools page for more information and downloads.

Click the link Flickr Tools page to open that page. On the Tools page, look for the heading Desktop Uploadr, and find these two links under that heading:

▶ Windows Vista & XP: Download (12MB)

▶ Mac OS X 10.5 & 10.4: Download (20MB)

Click the link for your operating system. Your browser will display a dialog box. Click the Save button and save the Uploadr download. When the download is complete, click the Run button.

Clicking the Run button launches the Uploadr installation program. To actually install Uploadr, follow these steps (for the Windows version):

1. Click the Next button.

2. Select a location on your hard disk to install Uploadr to, and then click Next.

3. On the next page, if you want a desktop shortcut icon for Uploadr to make it easy to launch, leave the Create Desktop Icon check box checked and click Install.

4. After installation is complete, click Finish.

Double-click the new desktop icon for Uploadr to run it. The first time you run Uploadr, you have to sign in to Flickr. To do that, click the Sign In button in Uploadr.

To sign in to Flickr, follow these steps:

1. Uploadr will display a dialog box explaining that you have to sign in to Flickr. Click OK.

2. This starts your browser. Find the text, "If you arrived at this page because you specifically asked Flickr Uploadr to connect to your Flickr account, click here," and then click the Next button under that text.

3. Flickr next displays this text:

 By authorizing this link, you'll allow Flickr Uploadr to:

 ▶ Access your Flickr account (including private content)

 ▶ Upload, Edit, and Replace photos and videos in your account

 ▶ Interact with other members' photos and videos (comment, add notes, favorite)

 Click the OK, I'll Authorize It button.

4. The next window in your browser has this message: "You have successfully authorized the application Flickr Uploadr." Close the browser window.

5. Go back to Flickr Uploadr and click the Ready! button.

Now you're ready to use Uploadr.

If you've already installed Uploadr, double-click it at this time to start it.

The easiest way to tell Uploadr what videos you want to upload is to drag videos into Uploadr. Just follow these steps:

1. Drag the videos to upload onto Uploadr, making the videos appear in Figure 7.6.

TIP

You can drag videos into Uploadr from any program that displays the name of the video. For example, in Windows, Windows Explorer is a good choice—navigate to the video to upload and then just drag it from Windows Explorer into Uploadr.

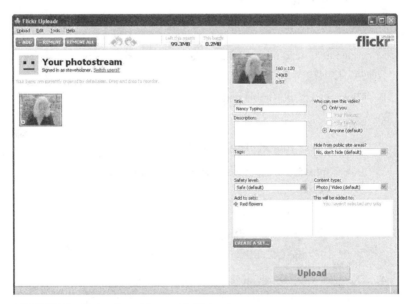

FIGURE 7.6 Uploading videos with Uploadr.

2. Select a video that you're uploading in Uploadr by clicking it.

3. Enter a title for the video in the Title box.

4. Enter a description for the video in the Description box.

5. Enter tags for the video in the Tags box.

6. Select the privacy options for the uploaded videos:

> ► Only You
>
> Visible to Friends
>
> Visible to Family
>
> ► Anyone (default)

7. Select whether you want to hide the videos from public site searches.

8. Select the safety level:

> ► Safe (default)
>
> ► Moderate
>
> ► Restricted

9. If you want to add the videos to a set, select the set from the Add to Set drop-down list box.

> TIP
>
> You can create a new set from Uploadr, too. Just click the Create a Set button.

10. Set the content type:

> ► Photos/Videos (default)
>
> ► Screenshots/Screencasts
>
> ► Illustration/Art/Animation/CGI

11. Select another video if you are uploading more videos and repeat steps 2 through 11 for any additional videos.

12. Click the Upload button.

13. After the upload is complete, Uploadr will display a dialog box. Click the Go to Flickr button in the dialog box, which opens the page you see in Figure 7.7.

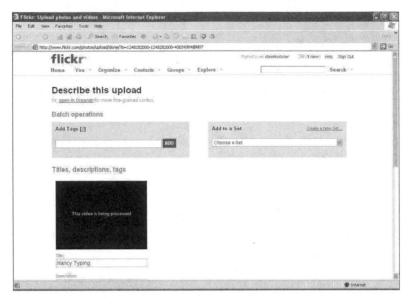

FIGURE 7.7 Describing an uploaded video.

14. If you're uploading more than one item and want to apply the same tags to all items, enter those tags in the Batch Operations/Add Tags text box.

15. If you want to add the upload to a set, select that set from the drop-down list box in the Add to a Set box.

16. Under each uploaded video, enter a title in the Title box.

17. Under each uploaded video, enter a description in the Description box.

18. Optionally, for each uploaded video, enter tags in the Tags box.

19. Click the Save button. Flickr will open your photostream or the set you added the videos to, as shown in Figure 7.8. (The new video is at the upper left.)

There's one more way of uploading video: You can email video to Flickr.

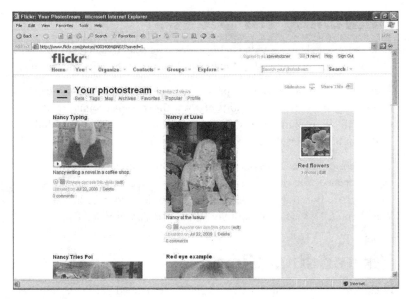

FIGURE 7.8 Your photostream.

Uploading with Email

You can also upload videos via email. Flickr assigns everyone a unique email address that you can use to upload video to. To find your unique email address, go to www.flickr.com/account/uploadbyemail/. Your email address will appear at the upper right.

To email videos to your photostream, you just attach the videos to the email and then send that email to your unique email address.

The email's subject becomes the title of the video, the body of the email becomes the description, and any words you place after the word "tags:" in the body become the tags.

Cool—now you can upload videos to Flickr using email.

Searching for Videos

How about searching for videos? Flickr lets you search for videos just as you can search for photos. Just enter search terms in the Flickr search box.

There are a few customizable aspects of searching for videos. You can exclude videos from search results at www.flickr.com/account/prefs/safesearch/. To exclude videos from search results, deselect the Include Videos in Search Results check box.

The videos on the video pages you open will play automatically when the page is opened. You can change that at www.flickr.com/account/prefs/autoplay/?from=privacy. Just select or deselect Yes under the heading Would You Like Videos to Autoplay When You View a Video Page?.

Embedding Video

Flickr can also give you HTML you can use to embed your videos in web pages. Just follow these steps:

1. Open the video's page. (For example, from your home page at Flickr.com, click the Your Photostream link, and then click the thumbnail of the video to open its page.)

2. Click the Embed Video link that appears above the video, opening the page you see in Figure 7.9.

3. Customize the video player by selecting or deselecting the Show the Video's Title and Owner at the Start check box.

4. Enter the size you want the player to display the video with in the two text boxes.

5. If you want to, click the arrow button on the video to display it using the options you've set.

6. Copy the HTML embedding code that appears at the bottom of the page.

7. Paste the HTML code into the page where you want the video to appear.

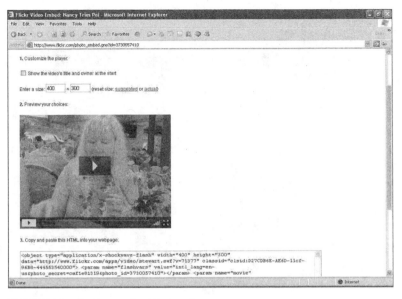

FIGURE 7.9 Getting embedding codes.

Summary

This lesson took a look at working with videos in Flickr. You saw that there can be limits on the number and size of videos. You also saw how to upload videos, how to set the search rules for videos, and how to get embedding HTML code that lets you display a video in a web page of your choosing.

LESSON 8

Favorites, Flickr Mail, and Printing

Flickr contains many items we haven't talked about yet, such as Flickr Favorites, Flickr Mail, content filtering, licensing, and printing.

Flickr Favorites lets you group your favorite photos together for easy access. You can mark photos as favorites, and they'll be ready for you to click on them to view.

Flickr Mail lets you communicate with other Flickr members. In fact, when you signed up, you already got your first piece of Flickr mail. In this lesson, we take a look at how it works—and how to send some yourself.

Licensing can be a tricky thing with photos, and we'll take a look at the topic here, including getting your photos licensed by Getty Images.

Finally, we'll take a look at how to print your photos from Flickr. There are plenty of companies ready to provide you with this service, and you'll see how they work here.

With all this coming up in this lesson, let's dig in immediately, starting with Flickr Favorites.

Welcome to Flickr Favorites

How do you add a photo to your favorites? It's not hard: Just navigate to the photo's page and click the Add to Faves button at the upper left above the photo, as you can see in Figure 8.1.

When you click the Add to Faves button, the star in the button becomes solid gold in color and the caption changes to A Fave.

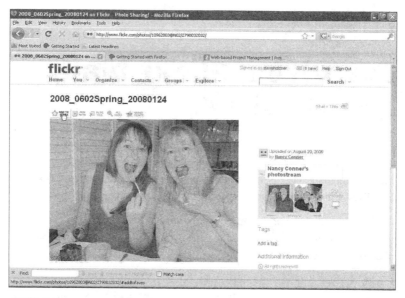

FIGURE 8.1 The Add to Faves button.

If you click the button again, the star becomes an outline again, and the photo is removed from your favorites.

TIP

Can you add your own photos to your favorites? Surprisingly, no. You can only add other peoples' photos as your favorites, not your own. This might seem odd, but that's the way Flickr is. Want to collect your own photos as favorites? Make a set instead.

How do you get a look at your favorites? There are two ways. Here's the first way:

1. Navigate to your home page at Flickr.com and sign in if you're not already signed in.

2. Click the down arrow next to the You menu.

3. Select the Favorites menu item.

This opens the Favorites page, as you can see in Figure 8.2.

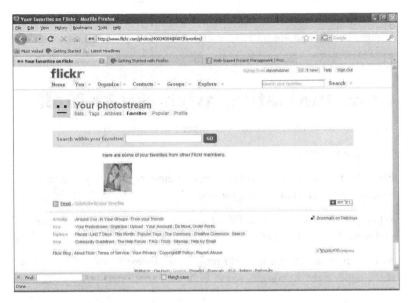

FIGURE 8.2 Your favorites.

> **TIP**
>
> Note that you can search through your favorites using the Favorites search box that appears in the Favorites page.

You can also reach the Favorites page this way:

1. Navigate to your home page at Flickr.com and sign in if you're not already signed in.

2. Click the Your Photostream link.

3. Click the Favorites link in the photostream page.

Want to see the full version of one of the thumbnails in your Favorites page? Just click the thumbnail to open the photo's page.

Want to delete a photo from your Favorites? Click the photo's thumbnail to open the photo's page, and then click the A Fave button to convert the gold star back to a simple outline. Easy.

That's about all there is to handling favorites. If you want to group together other peoples' photos together with your own, create a set; don't try to use Favorites.

Communicating with Flickr Mail

Is there a way to communicate with other Flickr members?

Yes, there is. You can use Flickr Mail.

Flickr Mail is an email system for Flickr members. In fact, you already have some Flickr Mail waiting for you.

When you signed up for your Flickr account, Flickr automatically sent you some Flickr Mail. Let's see if we can't take a look at that.

At the top of any logged-in Flickr page, you can see a link to Flickr Mail at the upper right, as you can see in Figure 8.3.

FIGURE 8.3 The Flickr Mail link.

If you're a new user, your link to Flickr Mail will look like an envelope with the text ("1 new") following it. As you can guess, that "1 new" text indicates you have one new Flickr Mail message waiting.

To see your Flickr Mail message, click the Flickr Mail link, opening the Flickr Mail page shown in Figure 8.4.

FIGURE 8.4 The Flickr Mail page.

Your Inbox

Welcome to the Flickr Mail page. By default, your Flickr Mail inbox is showing, and these columns are visible to display your new mail:

- ▶ Sender
- ▶ Subject
- ▶ Date
- ▶ Select All (Click this link to select all messages; otherwise, select individual messages with the check box in this column.)

Notice that our first Flickr Mail message is from Flicker HQ with the sub-
ject Welcome to Flickr! To read that mail message, click the subject link
to open the message in its own page, as shown in Figure 8.5.

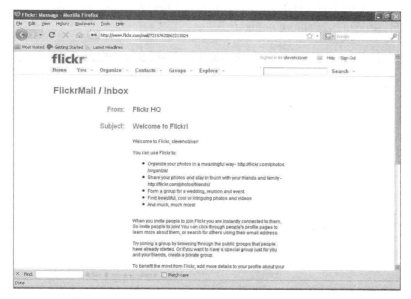

FIGURE 8.5 A Flickr Mail message.

As you can see, this message is just a generic Welcome to Flickr message
from the Flickr staff. If you want to delete it, click the Delete button that
appears at the bottom of the message; otherwise, click the Or, Return to
Your Message List link.

In this way, you can look at your Flickr Mail messages, deleting them as
you like or saving them.

TIP

You can also delete messages by checking the check box at the end
of the message's line in the Inbox and then clicking the Delete link
at the bottom of the Select All column. Clicking the Select All link at
the head of the Select All column selects all the messages, marking
them for deletion if you click the Delete link.

Your Contact Notifications

You also get notified through Flickr Mail when someone adds you as a contact.

You can see the contact notifications you've received by clicking the Contact Notifications tab in the Flickr Mail page, displaying the contact notifications, as shown in Figure 8.6.

FIGURE 8.6 Flickr Contact Notification.

When you open a contact notification, you'll see something like that in Figure 8.7.

In the contact notification message, you'll get a message something like this:

> Hi steveholzner,
>
> Yay! Nancy Conner has marked you as a contact too.
>
> Here's a link to Nancy Conner's profile and photostream.
>
> See ya!

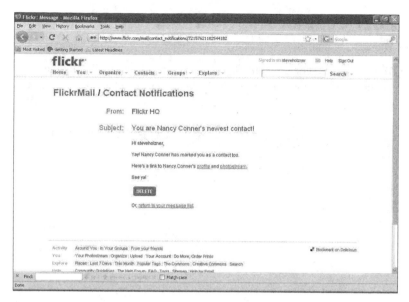

FIGURE 8.7 A contact notification.

Your Sent Mail

Want to take a look at the Flickr Mail you've already sent? Just click your Sent Mail tab in the Flickr Mail page, as shown in Figure 8.8.

Unfortunately, there's nothing here, because we haven't sent any Flickr Mail yet; all we get is the message, "You need to send a Flickr Mail before it gets displayed here."

How about sending some Flickr Mail and giving ourselves something to look at in the Your Sent Mail tab?

We'll do that next.

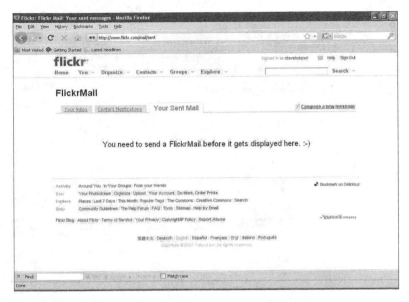

FIGURE 8.8 The Sent Mail tab.

Sending Mail

Want to send a Flickr member some mail? Just follow these steps:

1. Navigate to your home page at Flickr.com and sign in if you're not already signed in.

2. Click the Contacts link.

3. Click the Contact List link.

4. Find the person you want to send a message to in the Contact list and click the down arrow next to his or her buddy icon.

5. Click the Send Flickr Mail menu item, opening the page you see in Figure 8.9.

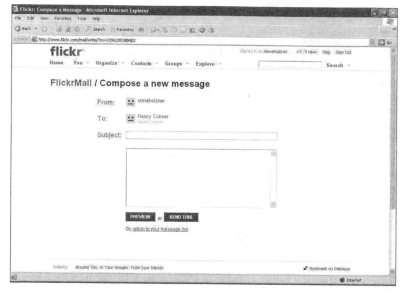

FIGURE 8.9 Sending mail.

6. Enter the subject of the message.

7. Enter the message itself.

8. Click the Preview button to get a preview of your message, or the Send This button to send your message. Alternately, click the Or, Return to Your Message List link to cancel sending the message at all.

When you send Flickr Mail, the sent messages appear in the Your Sent Mail tab, as you can see in Figure 8.10.

As you can see in Figure 8.10, the Sent Mail page has these column headers:

▶ Recipient

▶ Subject

▶ Date

▶ Select All (Click this link to select all messages; otherwise, select individual messages with the check box in this column.)

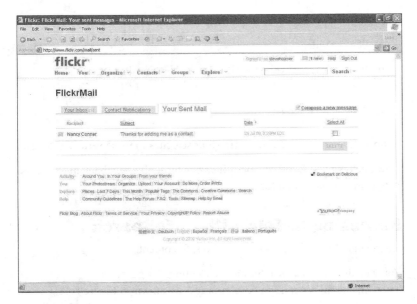

FIGURE 8.10 Sent mail.

To see a message you've sent, click its subject link.

And that's it for Flickr Mail. As you can see, it can provide a nice way for members to keep in contact.

All About Content Filters

The Internet is a wild-and-wooly place these days, and Flickr comes to the rescue with content filters.

You've already seen that when you upload content; you're expected to list what safety level that content is. Flickr gives these three safety levels:

- ▶ **Safe**: Content suitable for a global, public audience.

- ▶ **Moderate**: If you're not sure whether your content is suitable for a global, public audience but you think that it doesn't need to be restricted per se, this category is for you.

- ▶ **Restricted**: This is content you probably wouldn't show to your mom and definitely shouldn't be seen by kids.

You're also expected to set the content's type to one of these:

- ▶ Photos/Videos

- ▶ Illustration/Art/Animation/CGI or Other Non-Photographic Images

- ▶ Screencasts/Screenshots

It turns out that you can also restrict your searches to these various settings.

How does content filtering work? It works through a mechanism called SafeSearch, which is on for everyone by default.

Searching Safely with SafeSearch

SafeSearch, by default, restricts you to safe content.

You can also set your own SafeSearch settings by going to www.flickr.com/account/prefs/safesearch/, as shown in Figure 8.11.

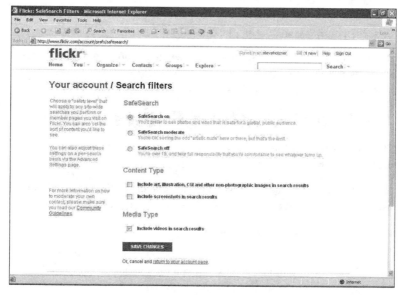

FIGURE 8.11 SafeSearch settings.

You can set the SafeSearch settings to these options, as given by Flickr:

- **SafeSearch On**: You'd prefer to see photos and video that is safe for a global, public audience.

- **SafeSearch Moderate**: You're okay seeing the odd "artistic nude" here or there, but that's the limit.

- **SafeSearch Off**: You're over 18 and take full responsibility that you're comfortable to see whatever turns up.

And you can set the content type possibilities to:

- Include Art, Illustration, CGI and Other Non-Photographic Images in Search Results

- Include Screenshots in Search Results

And you can include or exclude videos from search results:

- Include Videos in Search Results

If you can leave SafeSearch on, then by default when you do a search, it'll be in force and its rules will apply.

Moderating Your Own Account

When you upload content, you're asked to indicate what type of content it is and how safe. You can also set the default safety level settings for your account at www.flickr.com/account/prefs/filters/?from=privacy, as shown in Figure 8.12.

On this page, you can set the default safety level of the content you normally upload:

- **Safe**: Your photostream is suitable for a global, public audience.

- **Moderate**: Some of the things you upload might be considered offensive by some people.

- **Restricted (That's OK)**: Your photostream is unsuitable for children, your grandmother, or your workmates. (We recommend this setting if you're not sure of the difference between moderate and restricted, just to be on the safe side.)

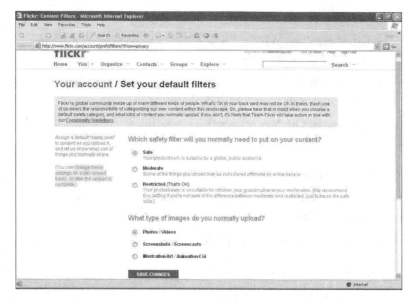

FIGURE 8.12 Default content settings.

And the default type of content:

▶ Photos/Videos

▶ Screenshots/Screencasts

▶ Illustration/Art/Animation/CGI

When you're done, click the Save Changes button.

You can moderate your own content, even after it's uploaded. Just follow these steps:

1. Go to your home page at Flickr.com and log in if you're not logged in automatically.

2. Click Organize to go to the Organizr.

3. Load all images (public, private, and friends/family) that need to be marked as Restricted.

4. Click Permissions and then click Set Safety Filter to set them as Restricted.

5. If you have images that should be marked as Moderate, repeat steps 3 and 4 for those also.

Sooner or later, your account will be reviewed by Flickr. If you're account is reviewed as safe, that means that you've moderated your content well. If your account is reviewed as unsafe, that means that Flickr thinks you've moderated poorly, and you account's content is excluded from searches.

How do you get your account re-reviewed? Go to this URL, which appears in Figure 8.13 www.flickr.com/help/contact/?cat_shortcut= review_account

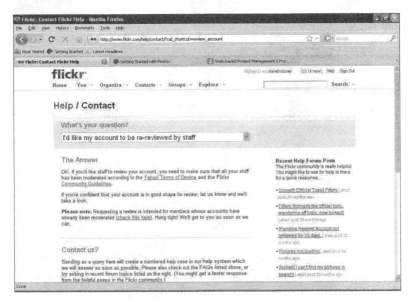

FIGURE 8.13 Getting your account re-reviewed.

Printing from Flickr

Printing from Flickr? Just how do you print from a website?

It turns out that Flickr partners with several printing services, which print the photos and mail them to you.

So how do you print a photo? You click the Order Photos link above any photo on that photo's page. Doing so opens the menu you see in Figure 8.14.

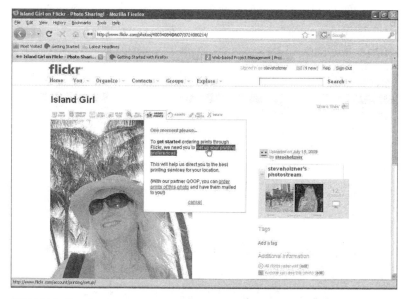

FIGURE 8.14 Setting up to print photos.

When you click Order Prints, the menu that appears asks you to click another link, set up your printing preferences, and when you click that link, you get a new page, as shown in Figure 8.15.

On this page, click Yes if you live in the United States. Otherwise, click No.

On the next page, as shown in Figure 8.16, select who can print your photos.

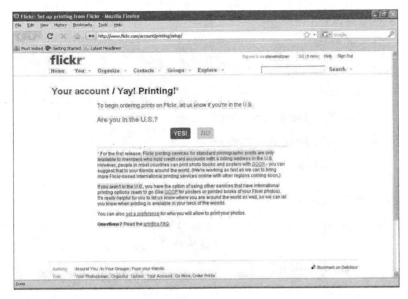

FIGURE 8.15 Getting ready to print photos.

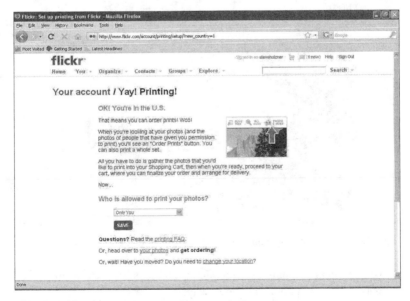

FIGURE 8.16 Select who can print your photos.

Here are the possibilities:

- ▶ Only You

- ▶ You and Your Family

- ▶ You and Your Friends

- ▶ You, Your Family, and Friends

- ▶ You and Any of Your Contacts

- ▶ Any Flickr Member

Now click the Save button.

Then, close and reopen the photo's page, and click Order Prints again. You'll see a menu open, as shown in Figure 8.17.

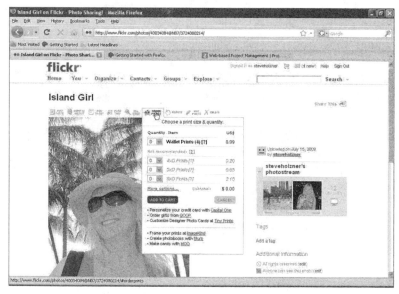

FIGURE 8.17 Selecting what size and number of copies to print.

Note that Flickr recommends minimum resolutions for each photo's size to make sure your photo comes out okay:

- ▶ Wallet Prints (x4) 525x375

- ▶ 4x6" 900x600

- ▶ 5x7" 1050x750

- ▶ 8x10" 1500x1200

- ▶ 20x30" 1600x1200

- ▶ 5x5 square 750x750

- ▶ 4xD (digital aspect) 900x600

- ▶ 5xD (digital aspect) 1050x750

- ▶ 8xD (digital aspect) 1500x1200

After making your choice, click the Add to Cart button, which displays a dialog box with two buttons: Continue Browsing and Proceed to Checkout. If you want to print other photos, too, click the first button. If you're ready to check out, click the second.

When you're ready to check out, click the Proceed to Check Out button, opening the page you see in Figure 8.18.

FIGURE 8.18 Checking out.

You can pick up your photos at Target or have them mailed to you. Select which option you want, and then confirm the quantity of each photo and click the Check Out button, opening the page you see in Figure 8.19.

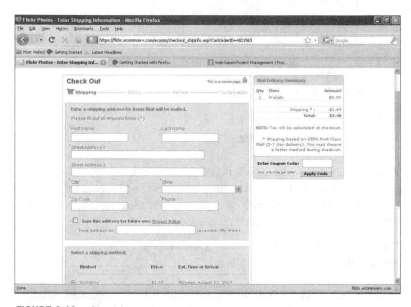

FIGURE 8.19 Checking out.

When you're done, click the Continue button and keep following the instructions to select a printing service, enter credit card information, and so on.

Getty Images

Getty Images, the photo repository, scans people's Flickr accounts, and extends invitations to some Flickr members to list their photos on Getty Images.

If you get an invitation to join the Flickr collection on Getty Images, you'll be asked to create an account with them, so you can become a Getty Contributor. What's involved in the sign-up process? Here are the main steps, according to Flickr:

- ▶ **Specify Your Profile**: Your name, email address, mailing address, whether you're signing up as an individual or a business.

- ▶ **Specify Your Payments**: Getty Images can pay Contributors almost anywhere in the world. So, you'll need to tell them where in the world you'd like to be paid and details about how to pay you, like your PayPal account or bank account information.

- ▶ **Specify Your Taxes**: Getty Images will be generating the relevant tax documentation expected by the country where you will be paid, so you will need to know your taxation number.

- ▶ **Specify Your Agreement**: You'll be signing a contract with Getty Images because they're helping to sell your work on your behalf. At this step, you'll be able to review the agreement based on the information you've entered. You'll have 90 days to digitally sign the agreement before it expires and you'll need to start again.

- ▶ **Specify Your Confirmation**: The final step is your chance to review everything you've entered against your (nearly) new Getty Images Contributor account. It's here that you'll actually agree to the agreement you reviewed in the previous step, and after you do, your new account will be opened.

If you're picked by Getty Images, congratulations; it's a chance to make some money.

Summary

This lesson took a look at many topics: Flickr Favorites, Flickr Mail, content levels, printing, and Getty Images.

Flickr Favorites lets you organize other people's photos into a Favorites folder of your own; Flickr Mail lets you keep in touch with your contacts via specialize email on Flickr; Flickr content levels let you set what kind of safety level the material you search for has. Flickr has partnered with various printing services to let you print your photos, and Getty Images lets you list your images for sale.

LESSON 9

Upgrading Your Account

So how does Flickr make its money? It's free, isn't it?

Well, yes and no. Like so many Internet business models, Flickr makes its money by offering premium services for a fee. Those services are known as the Pro package, and according to Flickr, this is what Pro gives you:

- ► Unlimited photo uploads (20MB per photo)
- ► Unlimited video uploads (90 seconds max, 500MB per video)
- ► The capability to show HD Video
- ► Unlimited storage
- ► Unlimited bandwidth
- ► Archiving of high-resolution original images
- ► The ability to replace a photo
- ► Post any of your photos or videos in up to 60 group pools
- ► Ad-free browsing and sharing
- ► View count and referrer statistics

Flickr is quick to point out that you get considerably less with a free account:

- ► 100MB monthly photo upload limit (10MB per photo)
- ► Two video uploads each month (90 seconds max, 150MB per video)
- ► Photostream views limited to the 200 most recent images
- ► Post any of your photos in up to 10 group pools
- ► Only smaller (resized) images accessible (although the originals are saved in case you upgrade later)

How many people have Pro? Flickr's not saying, but if it's like other, similar services that offer for-fee premium services, the fraction of Pro users might hover around 5% of the whole.

How much does Pro cost? As of this writing, it's $24.95 a year, which is pretty reasonable.

Okay, let's take a look at the world of Pro and sign up ourselves.

Signing Up

How do you go about actually signing up to make your account a Pro account?

Just follow these steps:

1. On your home page at Flickr.com, you'll find a link with the wording (by the time you read this, the wording might have changed):

 Holy smokes! That's cheap!

 Get a year of pro for $24.95

2. When you click the link, you see the page that appears in Figure 9.1.

FIGURE 9.1 The Pro page.

3. Click the Buy Now! button, opening the page you see in Figure 9.2.

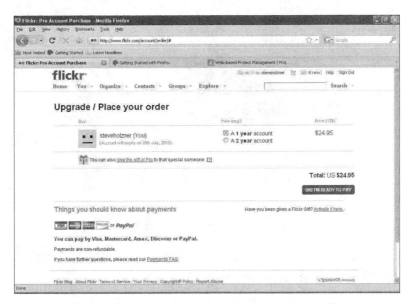

FIGURE 9.2 The Pro Upgrade/Place Your Order page.

4. Select the 1 Year or 2 Year radio button.

5. Click the OK I'm Ready to Pay button, opening the page you see in Figure 9.3.

6. Payments go through Yahoo! Enter your Yahoo! ID and password and click the Sign In button, opening the page you see in Figure 9.4.

TIP

What methods of payment does Flickr accept? You can pay for Flickr Pro using a variety of means: Visa, MasterCard, Discover, American Express, or PayPal.

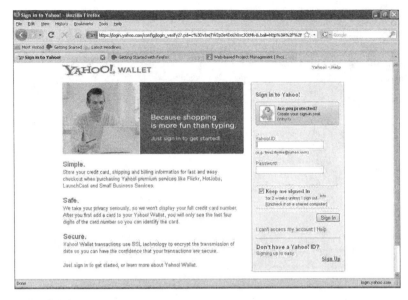

FIGURE 9.3 The Yahoo! Wallet page.

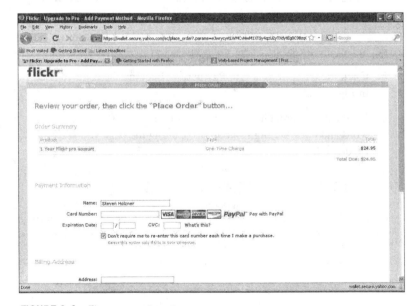

FIGURE 9.4 The payment page.

7. Enter your name (if Yahoo! hasn't already entered it).

8. Enter the credit card number.

> **TIP**
>
> There might be a credit card already entered when you check out, and you might want to change that. Flickr says, "Flickr uses Yahoo! Wallet for checkout. If your Yahoo! ID has a Wallet associated with it, you will automatically see the credit card on file in your Wallet. If you want to change the credit card number or billing address you can click 'change.' You will then be able to edit, delete, or add a credit card."

9. Enter the card's expiration date.

10. Enter the CVC code from your card.

11. Enter your address.

12. Enter the second line of your address, if applicable.

13. Enter your city.

14. Enter your state.

15. Enter your postal code.

16. Enter your country. (The default is the United States.)

17. Check the I Have Read and Agree to the Additional Terms of Service and the Payment Obligations Contained Therein check box. (To read the terms of service, click the Additional Terms of Service link.)

18. Click the Place Order button.

It takes Flickr some time to process your order (usually less than 24 hours). When you click the Place Order button, a page with this message will appear:

> FlickrHQ has received your order for $24.95 worth of Pro Account goodness, BUT, we are still processing your transaction. We're not exactly sure when your payment will go through, so we'll send you an email when your transaction is complete.

There's a link to Your Order History in this page. Clicking it confirms that you've ordered a year (or two) of Pro, as shown in Figure 9.5.

FIGURE 9.5 Your order history.

The confirming email can take quite some time to come. Impatient? You can tell if your account has been upgraded to Pro or not by looking at your photostream.

Just go to your home page at Flickr.com and click the Your Photostream link. If you see the icon "pro" after the title Your Photostream (see Figure 9.6) you've been upgraded to Pro.

What happens if your Pro account expires? Does it automatically renew? Do your extra photos and videos get deleted?

No to the last two questions. Your account doesn't automatically renew (which would involve charging your credit card). And your extra photos and videos—those that put you over the limits of a free account—don't get deleted.

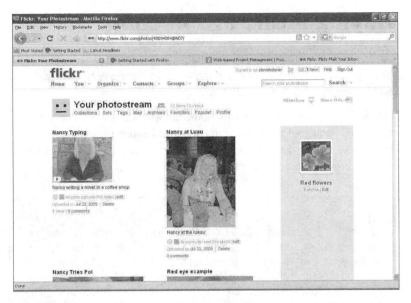

FIGURE 9.6 Confirming that your account is Pro.

However, those extra photos and videos will "disappear." You'll no longer be able to see them in your account. To restore those photos, and videos, and sets, sign up for Pro again, and they'll be there, waiting for you.

Can you buy a Pro account for someone else? Yes, you can.

TIP

Yahoo! is actually a little persnickety when it comes to orders placed through PayPal; it checks all your information. If you get errors when placing an order through PayPal, you should

▶ Check that the address, postal code, and all other information in your PayPal account and funding sources are up-to-date.

▶ Check that you have enough funds in your account.

▶ Try deleting PayPal from your Yahoo! Wallet and re-adding it.

▶ PayPal has fraud checks like any payment site. Because of this, in some cases, you might need to have double the funds in your account or a backup funding source like a credit card.

Buying a Gift Pro Account

You can buy a Pro account for anyone.

What you actually buy is an activation code that you give to someone, which they use to active their Pro account.

If you've bought a Pro account for someone who's already a Flickr member, that person goes to the activation page and enters the code. If the person you've bought the Pro account for doesn't have an account, that person can create an account as part of the activation process.

> TIP
>
> Remember that having a Flickr account means you must have a Yahoo! account, too, and creating both can take some time. So before you buy that gift Pro account for Aunt Edith, better check with her or Uncle Ralph to make sure they're interested in going through the whole account-creation process. It's not just a matter of getting a free Pro account and—bang!—the account exists.

Do gift codes expire? Nope. They remain active until they are either activated or they are applied to your account.

> TIP
>
> Flickr has a lot of patience here, but if a gift code hasn't been activated within 12 months, your account is credited with the amount of the gift.

Gifts are the same price as regular upgrades.

If you send a gift card to someone who doesn't want it, you can send the same activation code to someone else—but note that the first person who activates it gets the Pro account.

How do you actually buy someone a gift? Follow these steps:

1. Go to the gift page, www.flickr.com/gift, as shown in Figure 9.7.

FIGURE 9.7 The gift page.

2. Click the big Buy Now button.

3. Choose the number of gifts you want to buy.

4. Select the 1 Year or 2 Year radio button.

5. Click the OK I'm Ready to Pay button.

6. Payments go through Yahoo! Enter your Yahoo! ID and password and click the Sign In button.

7. Enter your name (if Yahoo! hasn't already entered it).

8. Enter the credit card number.

9. Enter the card's expiration date.

10. Enter the CVC code from your card.

11. Enter your address.

12. Enter the second line of your address, if applicable.

13. Enter your city.

14. Enter your state.

15. Enter your postal code.

16. Enter your country. (The default is the United States.)

17. Check the I Have Read and Agree to the Additional Terms of Service and the Payment Obligations Contained Therein check box. (To read the terms of service, click the Additional Terms of Service link.)

18. Click the Place Order button.

19. Choose to either print a PDF Gift Card or email the gift. The recipient only needs to know where to go to activate the gift and the special magic gift code.

TIP

Sometimes, you can find people selling what appears to be Pro account gift codes at a discount, but you should steer clear. Flickr says, "As the saying goes, if it sounds too good to be true, it probably is. This usually means someone is selling a gift code on an auction or some such site. You can only purchase Flickr Pro accounts from Flickr through Yahoo!. Flickr Pro gift codes are not eligible for resale. A Flickr member who purchases such codes from such sales will lose their Pro status and will likely be out of any money they have spent when such transactions come to our attention. It will not be refundable by Flickr/Yahoo!."

What You Get

There are all kinds of advantages that you get when you enroll in a Pro account and for not much money.

But what exactly do you get? Let's take a look.

Unlimited Photo Uploads

You get to stuff as many photos into Flickr as you can; there's no monthly limit, period.

In other words, you can upload one photo a month or a zillion.

Does that mean that you get to upload those super-high-resolution 40MB photos? Unfortunately not—there is still a limit on photo size: 20MB per photo. You can't exceed 20MB per photo, even with a Pro account.

So when it comes to uploads, plan ahead—not on total upload size, but on individual photo size—100 MB monthly photo upload limit (10MB per photo).

> **TIP**
>
> You might think the 20MB per photo limit is overly restrictive if you're a professional photographer, but keep two things in mind. First, free accounts are limited to 10MB per photo (and 100MB uploading limit per month), and second, people will have to download your photos. So, think about how long it would take to download an image that's more than 20MB in size.

> **TIP**
>
> Here's another thing to think about: With a free account, your photostream views are limited to the 200 most recent images. That's not the case with a Pro account.

Unlimited Video Uploads

Video is becoming a bigger topic on Flickr, and if you're going to use Flickr for videos, you should really get a Pro account. The cost justifies what you get in terms of video capacity.

So what do you get? Unlimited video uploads, that's what.

Does that mean you can upload a thousand videos a month? Yes, it does indeed.

Does it mean you can make each video as big as you want it? No, it turns out, it doesn't.

There are still limits on videos on Flickr, even for Pro accounts. You can't upload that rip of the original *Tarzan* movie or even that favorite *Star Trek* episode. You're limited to videos that play for 90 seconds maximum and have a file size of 500MB per video or less.

Why is this? Why this limit? That's because Flickr still fundamentally considers itself a photo-sharing site, not an unlimited video-sharing site. They're definitely dipping their toes in the water, but Flickr's not ready to make the jump yet to fully fledged YouTube-style video storage.

Whether or not Flickr will ever be ready to make this jump is an open question. As storage media gets cheaper, the odds get better, and we'll probably see the size limits on each video increased.

> TIP
>
> Although the video limits might seem harsh, keep in mind that the restrictions on free accounts are far worse: You can upload only two videos per month, and each one can't be greater than 150MB.

You Can Show HD Video

Here's another way that Flickr is dipping its toes into the video pool: by allowing high-definition video.

But only for Pro users. HD video isn't available for free users. If you've got a Pro account, you can upload HD video and display it in your photo-stream, no problem.

Does this mean the limits on videos are increased for HD videos? Nope, videos still must be 90 seconds max and under 500MB. In fact, that's why the limit for videos are 500MB for Pro users—for HD videos.

One can just imagine the Flickr staff viewing the increasing size of video files with great alarm as videos are increasingly becoming HD. They're still hobbling videos in general with a 90-second limit.

TIP

Actually, free users can upload HD video—but it won't appear in your photostream. That is, people won't be able to access the HD video you upload. But it's still there, just waiting. Waiting for what? Waiting for you to upgrade to a Pro account, when all your HD videos will become instantly viewable (as long as they meet Flickr's size requirements for Pro users).

Unlimited Storage

As you might have guessed from the discussion of photo and video storage, you now have unlimited disk storage for your media.

And that does mean unlimited storage—which would be more impressive if there were no size limits per photo and video.

In any case, it's nice to know you don't have to worry about bumping into disk limits or upload limits for that matter!

Unlimited Bandwidth

Just as you now have unlimited disk space, you now also have unlimited bandwidth for uploading and downloading.

That means that people can download as much of your collection as they want without fear of being limited.

Archiving of Original Images

As you know, if you have a free account, Flickr chooses the sizes it decides to show your images as. But it's different for Pro users.

For Pro users, Flickr stores your original image size without shrinking it. And people can view the original when they click the Available Sizes: Original link above the photo on the photo's page, as shown in Figure 9.8.

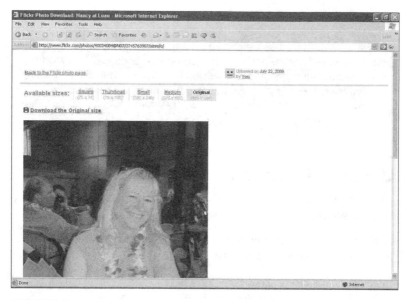

FIGURE 9.8 Accessing the original size of a photo.

That means that your photos will be stored with the resolution you want and the size you want.

> **TIP**
>
> This contrasts with free accounts, where only resized—that is, smaller—images are available. Actually, the original images are also saved, but they're not accessible while your account is a free one. Upgrade to Pro, and you'll find all your images accessible in their original forms.

Post to More Groups

You're limited in the number of groups you can post a photo or video to if you have a free account, but the limit is greatly expanded if you have a Pro account.

If you have a Pro account, you can post an image or video to up to 60 group pools at once. That might seem like a lot more groups than you're

likely to post to, but the truth is when you get into posting to groups, a lot of allied groups come to your attention. So it's not unusual to find yourself posting to 20 groups.

Sixty groups is really enough for most purposes.

TIP

What's the limit for free accounts? If you have a free account, you can post a photo or video to up to 10 group pools—that's all. Compare that to 60 for Pro accounts.

Ad-Free Browsing and Sharing

You don't have to worry about ads when you upgrade from a free account to a Pro account. Pro accounts are free of ads and all kinds of similar distractions.

Free accounts usually don't display ads, but Flickr is holding the door open for them for the future. Pro users don't have to worry.

View Your Statistics

Here's a nifty feature only available to Pro users: statistics (which Flickr calls stats).

Stats are designed to give you some insight into how people are finding your photos and where they're coming from.

To enable stats (they're not on by default), click the You menu on your home page and then click the Your Stats menu item, opening the page you see in Figure 9.9.

To activate your stats, click the Yes! Activate Me! button.

When you do, you see a page telling you that your stats are under construction. It can take, Flickr says, up to 3 days for your stats to be collected and displayed.

When your stats are ready, you'll see them on the Stats for: Your Account page, as shown in Figure 9.10. (Note that your own views of your own photos and videos are *not* counted.)

FIGURE 9.9 Setting up stats.

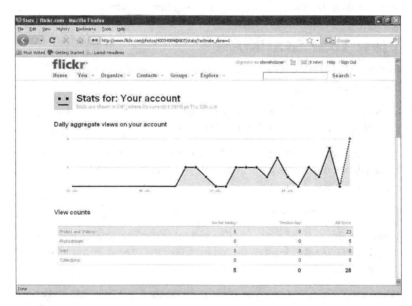

FIGURE 9.10 Looking at your stats.

In addition to an overall aggregate, Flickr breaks the stats up into views for these areas:

- ▶ Photos and Videos
- ▶ Photostream
- ▶ Sets
- ▶ Collections

Flickr lists your most-viewed photos and videos and also lists where the people viewing your media come from, using these categories:

- ▶ Flickr
- ▶ Search Engines
- ▶ Other Sites
- ▶ Unknown Source

Finally, Flickr Stats presents a breakdown of all your photos and videos, presenting you with such data as the following:

- ▶ How many are tagged and how many are not
- ▶ How many are geotagged
- ▶ How many are in sets
- ▶ How many photos you have
- ▶ How many videos
- ▶ How many are friends only
- ▶ How many are family only

All in all, stats are very cool. If you're a Pro user, enable them right away. You're probably going to be surprised at how many page views your photos are getting—and not even from Flickr users at that, but people coming from search engines.

Summary

This lesson took a look at upgrading your account from free to Pro and the benefits of doing so.

We took a look at how to upgrade your account—and how to buy a gift upgrade for a friend. Then we took a look at the features you now have access to as a Pro member, and they're considerable, everything from unlimited storage to being able to post an image to up to 60 groups.

Finally, we took a look at the Flickr Stats feature, available only to Flickr Pro users, and saw the kinds of data stats has to offer us about who's been looking at our photos and videos.

Index

T

U

FREE Online Edition

Your purchase of **Sams Teach Yourself Fl**
access to a free online edition for 45 days
Online subscription service. Nearly every
online through Safari Books Online, alon
technical books and videos from publishe
Professional, Cisco Press, Exam Cram, I
Hall, and Que.

SAFARI BOOKS ONLINE allows you to s
cut and paste code, download chapters,
emerging technologies.

Activate your FREE Online
www.informit.com/safari

STEP 1: Enter the coupon code: XGCLWWA.

STEP 2: New Safari users, complete the brief registration form.
Safari subscribers, just log in.

If you have difficulty registering on Safari or accessing the online
edition, please e-mail customer-service@safaribooksonline.com

Safari
Books Online

Addison
Wesley

AdobePress

ALPHA

Cisco Press

FT Press

IBM
Press.

Microsoft
Press

New
Riders

O'REILLY

Peachpit
Press

PRENTICE
HALL

QUE

Redbooks

SAMS

SAS

Sun

WILEY